SEMINAR PROCEEDINGS

Discipline-based Art Education and Cultural Diversity

August 6–9, 1992

Austin, Texas

**A National Invitational Seminar Sponsored by
the Getty Center for Education in the Arts**

Library of Congress Cataloging–in—Publication Data

Discipline-based art education and cultural diversity:
seminar proceedings, August 6–9, 1992, Austin, Texas.

 p. cm.

 Spine title: DBAE and cultural diversity.

 Includes bibliographical references.

 ISBN 0-89236-279-0

 1. Art—Study and teaching—United States—His-
tory—20th century—Congresses. 2. Multicultural-
ism—United States—Congresses.

I. Getty Center for Education in the Arts. II Title:
DBAE and cultural diversity.

N108.D57 1994

707′.073—dc20 93-39091

 CIP

Cover illustration:
Hunter and ibex
Remigia, Spain
10,000 to 6,000 B.C.

TABLE OF CONTENTS

FIFTH PLENARY SESSION
Implications for Evolving DBAE Practice

SIXTH PLENARY SESSION
Affinity Group Summary Reports

FOREWORD

The purpose of the Getty Center for Education in the Arts' third seminar on the development of discipline-based art education (DBAE) theory was to enable art teachers, academic art educators, general classroom teachers, museum educators, artists, art historians, critics, and aestheticians—and the Center's staff—to discuss points of view pertaining to cultural diversity and DBAE. The objective of these discussions was to contribute to the evolving theory and practice of DBAE.

DBAE and Cultural Diversity took place in a context larger than DBAE, however—it took place in the context of cultural diversity and its impact on society. The classic image of America as a melting pot, where differences of race, wealth, religion, and nationality are submerged, is being challenged. The idea of assimilation into the mainstream is giving ground to the recognition of ethnicity and diversity.

This upsurge in ethnic awareness and diversity is having some healthy consequences, including long overdue recognition of the achievements of women, African Americans, Indians, Latinos, Asians, lesbians, and gays. Unquestionably, America's population is becoming more heterogeneous and will continue to do so. It has been predicted that by the year 2000, 34 percent of children under the age of eighteen will be African American, Latino, Asian, or mem-

bers of another minority. By the year 2010 this proportion will rise, and today's minority children will become the majority in California, New York, Texas, and Florida.

A fundamental issue accompanying these realities is how such a highly differentiated society will hold itself together. Can the arts play a role by providing a common ground that transforms cultural differences? Can arts education demonstrate that diversity need not divide? Can it demonstrate that plurality can be a benefit and not a burden? Can education in and through the arts make a contribution to building mutual respect, understanding, and tolerance? And, can the conceptual approach to teaching art, known as discipline-based art education, make a contribution?

We believe that it can. We believe that DBAE has the capacity to embrace works of art from different cultures and to embrace diverse forms of aesthetic perception and valuing. Through seminars such as *DBAE and Cultural Diversity,* we had the opportunity to discuss how DBAE can embrace cultural diversity more effectively.

One of the Center's expectations for this seminar was that it would contribute to the evolution of DBAE theory and practice. The participants also had expectations. University and college faculty, for example, came looking for a broader and clearer understanding of multiculturalism as it applies to the theoretical

underpinnings of DBAE. Some participants were anxious to explore what criteria to use when deciding what to leave out of the curricula and what to leave in. Many in higher education also hoped to find ideas that could be applied to teacher education programs and to ongoing research.

Some art teachers wanted to learn how issues of cultural diversity are expected to impact the art disciplines, while others looked for practical strategies for fielding questions from students in ways that reflect cultural awareness and sensitivity. Still others sought ways of introducing students to new production techniques without trivializing them through decontextualization.

General classroom teachers looked for more information on instructional resources on works of art from non-Western cultures so that they could expand their teaching in art, as well as in reading, history, and social studies. Other teachers wanted to know how to balance the competing interests of various cultures with the attraction of a single American culture with shared values and traditions.

Museum educators were interested in learning how university and school educators were thinking about diversity issues. They wanted to know if these educators have found effective pedagogical approaches to introducing new ways of thinking about culture that might be relevant to their own work in museums.

Clearly, the expectations that participants brought to this three-day convocation were varied. Realistically, not all of them could be addressed to everyone's satisfaction. We anticipated that over the seminar's three days there would be more questions asked than answered. We hoped, however, that those who attended the conference and those who read the proceedings will have been more intellectually provoked than satisfied. If this has happened, the seminar will have been a success and will have achieved its purpose; namely, to have served as a catalyst for stimulating thinking and discussion of how DBAE can more effectively embrace cultural diversity and the many cultural traditions that comprise the worlds of art.

Leilani Lattin Duke
Director
Getty Center for Education in the Arts

INTRODUCTION

In August 1992, the Getty Center for Education in the Arts convened its third issues seminar for the theoretical development of discipline-based art education (DBAE) in Austin, Texas. Devoted to the topic of DBAE and cultural diversity, the seminar was designed to provide an opportunity for an invited audience of educators and researchers knowledgeable about and engaged with DBAE to critically examine and reflect upon the issues of cultural diversity as they pertain to evolving DBAE theory and practice. To achieve this purpose, *DBAE and Cultural Diversity* was structured around five basic themes:

1. perspectives on cultural diversity in education;

2. perspectives on DBAE and cultural diversity;

3. the effect of cultural diversity upon practices in art history, aesthetics, criticism, and art making;

4. experiences in other disciplines that affect DBAE; and

5. implications for evolving DBAE practice.

As a way of stimulating further discussion, several affinity group breakout sessions facilitated by participants representing museum education, teacher education, art education, administration,

and supervision were held at various points throughout the seminar. A resource center featuring multicultural art education videos, films, slides, posters, and books was open throughout the seminar (a listing of these resources appears at the end of the book). Finally, the Center's staff selected videos on various aspects of cultural diversity were aired on the conference center's closed-circuit television for participants to view at their leisure.

THE ISSUES SEMINARS SERIES

The Center supports five program areas in its commitment to development of DBAE theory and the implementation of DBAE: advocacy, professional development, theory development, curriculum development, and demonstration programs. The philosophical basis of the theory development program area is that the theoretical underpinnings of DBAE need to evolve continuously to provide a strong foundation for professional development, classroom practice, assessment, and research. One of the ways the Center has supported theoretical development has been through the sponsorship of Issues seminars or forums for presenting information, ideas, and new perspectives as they apply to DBAE research and teaching.

In May 1987, the Center sponsored its first seminar, *Issues in Discipline-Based Art Education:*

Strengthening the Stance, Extending the Horizons.
Thirty-seven art educators met in Cincinnati for three days to present and respond to papers structured around several basic issues:

1. child development and the cognitive styles children use when learning,

2. art and its societal role, and

3. art education curriculum reform.

Proceedings summarizing the reactions and recommendations of Issues I participants were published in 1988.

The Center's second issues seminar, *Inheriting the Theory: New Voices and Multiple Perspectives on DBAE,* was held in May 1989. More than 130 art educators spent three days in Austin presenting and responding to papers structured around five basic issues or, as the Issues II Planning Committee termed them, "triangulation" sessions. This approach allowed for three different perspectives on each of the following topics:

1. the integration of art history;

2. the role of aesthetics and criticism in the creation of new works of art;

3. DBAE teaching effectiveness, evaluation, and cognition;

4. philosophy and aesthetics; and

5. DBAE and the concerns of multicultural education.

The proceedings from *Inheriting the Theory* were made available in 1990.

DBAE AND CULTURAL DIVERSITY

As has been the case with previous seminars, at least two years before *DBAE and Cultural Diversity,* the Center's staff began an extensive preparation process. Because the Issues seminars fall under our program area of theory development, we felt it essential for our preparation to include an examination of the theoretical basis of cultural diversity and multicultural art education. This examination included the following activities:

1. Developing a bibliography of scholarly articles, news articles, books, and resources on multicultural art education for the Center's program staff. This bibliography includes philosophical, sociological, and legal writings as well as those pertaining to practical applications in K–12 and higher education.

2. Convening six day-long orientation meetings for staff on multicultural art education issues with art educators, scholars, policy makers, and teachers, who were commissioned to write

briefing papers. Many of these authors became Issues III speakers. Others—such as James Sears, Department of Educational Leadership and Policies, University of South Carolina; Tomás Miranda, Bilingual Education and Equity, Connecticut State Department of Education; Howard Simmons, Middle States Commission on Higher Education; and Brenda Welburn, National Association of State Boards of Education—are recognized for their expertise in multicultural education issues.

3. Visiting a group of mid-Atlantic schools identified by their mission statements as either being multicultural or having art programs designed to meet the needs of culturally diverse student bodies through a DBAE approach. This tour revealed a wide range of multicultural instructional strategies, e.g., human relations, social reconstruction, bicultural/cross-cultural analysis, value-free education, collaborative learning, and monocultural approaches.

4. Sponsoring a round table devoted to the topic of DBAE and cultural diversity with educators and representatives of community arts organizations from the greater Miami area. The purpose of this round table was to hear how diversity has changed the nature of their jobs and their interaction with one another.

The other activities we undertook to prepare for Issues III included a survey of multicultural instructional strategies used in our own regional staff development institutes. The authors of "DBAE: Becoming Students of Art" (Clark, Day, and Greer, 1987), one of the influential and defining monographs for DBAE, were surveyed to identify issues and/or themes they felt essential to be covered at Issues III. A similar survey was taken of our own program staff. The results of these surveys and activities, vetted over a period of two years with the Center's Advisory Committee and the Issues III Advisory Committee, enabled us to identify the seminar's audience and to structure a program we felt would elicit ideas essential to understanding the complexity of topics related to cultural diversity and DBAE.

Many concepts and ideas emerged from Issues III. In the discussions of how cultural diversity has affected the practice of DBAE, the following themes consistently emerged: the need for individuals to examine their own biases, attitudes, and/or sensitivities and the need to make theory, language, and terminology both relevant and accessible to the realities of everyday practice. This process of self-examination was seen as being particularly significant to art museums, where the effects of cultural diversity upon art history, aesthetics, art criticism, and art making

have been, in some instances, more readily seen than in the classroom.

In general, participants felt all institutions need to establish concrete goals for change and that such changes should represent a diversity of values and aesthetic persuasions as well as address issues of cultural ethos in underlying value systems and power bases. As disseminators of art education, schools, universities, and museums have the ability to expand the "canon" and sponsor new modes of art education. With regard to an expanded role for teachers of art in theory development, most participants felt greater collaboration was essential to develop theories that adequately embraced issues of cultural diversity at the local level and to address the needs of various learning styles. In short, the need to create solidarity as well as solidify relationships, both inside and outside the disciplines, was a consistent Issues III theme.

We are deeply indebted to the 150 Issues III participants and speakers, each of whom so willingly shared their ideas and opinions with us during the seminar. I am particularly grateful to the Getty Center for Education in the Arts staff, as well as the Issues III Seminar Advisory Committee. Without their support and guidance, *DBAE and Cultural Diversity* would not have been possible.

Thandiwee Michael Kendall
Program Officer
Getty Center for Education in the Arts

Perspectives on Cultural Diversity in Education

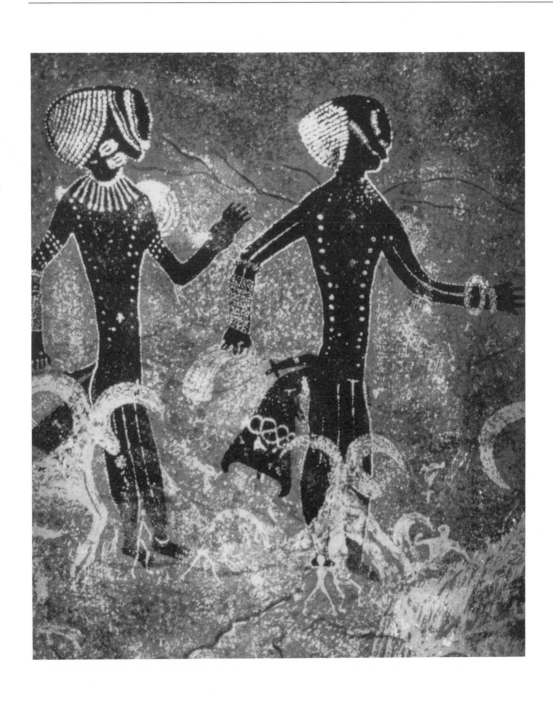

Two figures in finery
Tassili N'Ajjer, Algeria
6,000 years before present

INTRODUCTION

LEILANI LATTIN DUKE
Director
Getty Center for Education in the Arts

Following remarks that appear in this volume as the "Foreword," Leilani Lattin Duke noted that it was a pleasure to see so many old faces from the Center's Issues I and II seminars and so many new faces. She explained that it was a special pleasure to welcome all of the participants and introduced the speakers for the first plenary session.

Bernice Johnson Reagon is a specialist in African American oral performance traditions. She founded, and currently serves as the artistic director of Sweet Honey in the Rock, an internationally acclaimed African American women's a capella quintet, whose repertory focuses on African American song and singing traditions. Dr. Reagon is curator in the Division of Community Life in the Smithsonian's National Museum of American History. Her latest book is *We'll Understand it Better By and By: Pioneering African-American Gospel Composers.*

Carl Grant is a prolific contributor to multicultural education and teacher education, having authored some thirteen books and monographs on these subjects. In 1982 and 1983 he studied multicultural education in England as a Fulbright Fellow, and in 1990 he was named one of the top leaders in teacher education by the Association of Teacher Educators. As a faculty member at the University of Wisconsin, Madison, Dr. Grant continues his scholarship and teaching in the Department of Curriculum and Instruction and also in the Department of African American Studies. He has coauthored several books with Christine Sleeter, including *Making Choices for Multicultural Education, After the School Bell Rings,* and *Turning On Learning.*

Christine Sleeter is the Director of the Ethnic Studies Center and Professor of Teacher Education at the University of Wisconsin's Parkside Campus in Kenosha. Her most recent books include *Empowerment through Multicultural Education* and *Keepers of the American Dream.* In addition to the books she has coauthored with Dr. Grant, she contributes regular articles to the *Harvard Educational Review, Teachers College Record,* and *Phi Delta Kappan.* She is currently editing a series of books for the State University of New York entitled "Social Context of Education."

Rachel Mason is currently head of the Centre for Postgraduate Teacher Education at Leicester Polytechnic in England, where she supervises postgraduate research. Her major research interests are in the areas of multicultural education and ethnographic approaches to the study of the arts in culture. Dr. Mason is the author of *Art Education and Multiculturalism,* and a recent article,

"Art and Multicultural Education: The New Ethnicity in the U.K." has been translated into four languages. Dr. Mason is currently vice president of the International Society for Education through Art.

Ellen Dissanayake is the author of two books, *What Is Art For?* and *Homo aestheticus: Where Art Comes From and Why*. Ms. Dissanayake's multicultural perspective and interest in the development of the arts in human societies grew out of her experiences living in Sri Lanka, Papua New Guinea, and Nigeria for fifteen years. She will continue research in Sri Lanka on a Fulbright lecturing/research award.

OPENING REMARKS

BERNICE JOHNSON REAGON
Curator
Division of Community Life
National Museum of American History
Smithsonian Institution
Washington, D.C.

After singing her own interpretation of Charles Wesley's hymn, "Father, I Stretch My Hand to Thee," Bernice Johnson Reagon began her opening address by recalling her early experience in an African-American Southern Baptist congregation that was fascinated with the hymns of the Wesley Brothers, Charles and John. From the United Methodist Hymnal, Reagon read John Wesley's 1761 instructions to those who would sing his hymns: "sing them exactly as they are printed here without altering them or mending them at all. And if you have learned them otherwise, unlearn them as soon as you can." Another of Wesley's injunctions that she departed from included his insistence on singing modestly, not above or ahead of the other voices. But the third and seventh instructions revealed to Reagon that she and Wesley shared a similar viewpoint: "sing lustily and with courage," and "above all, sing spiritually."

Reagon noted that by virtue of her identity, she has been forced to be multicultural. African Americans, in fact, have used both the African and European repertory to develop unique expressions that would be unrecognizable to their predecessors: "It is no longer the same language, no longer the same song." The knowledge that one's own versions of things, including her version of Wesley's hymn, are right and valid must be "held within your person, within your classroom, within your life, and within your culture."

Because of its diversity, the United States of America demands that we all face this challenge. Reagon cited Herman Melville, who wrote:

> There is something in the contemplation of the mode in which America has been settled, that in a noble breast should forever extinguish the prejudices of national dislikes. Settled by the peoples of all nations, all nations may claim her for their own. You cannot spill a drop of American blood without spilling the blood of the whole world . . . our currents of blood is as the flood of the Amazon, made up of a thousand noble currents, all pouring into one. We are not so much a nation as a world.

These words express the potential of American society, which could be regarded as an experiment in whether or not people of all backgrounds and circumstances can live together and still survive.

In 1903, W.E.B. Du Bois wrote "Your country, how came it yours? Before the pilgrims landed, we were here." Reagon recalled that as a curator at the Smithsonian Institution, she directed a project within the bicentennial exhibition entitled "Old Ways in the New World." It detailed the wide range of cultural backgrounds, including African, South American, and Caribbean, that were encompassed within the African-American experience. One of the exhibits dealt with the material and sacred culture of Haiti. Despite the misgivings of the Smithsonian, practitioners of Voodoo were included, as were other practitioners of charismatic religions, such as Baptists from southwest Georgia.

Reagon believed that this festival was significant because it implied that the national museum had acknowledged the fact that certain human beings are living artifacts because they are survivors. African Americans "really do believe that human beings have souls. We have a culture structured to nurture that side of our being."

Because of their circumstances, Reagon continued, African Americans have been forced to take their forms of expression and "clean them up, tighten them, batten them down, so that they can be sterile, inactive, representations of what they were, in fact, created to be." This is simply an acknowledgment that the system they live under has cast them as the "other." However, as Du Bois once noted, "We have actively woven ourselves with the very warp and woof of this nation. We fought their battles, shared their sorrow, mingled our blood with theirs, and generation after generation we have pleaded with a headstrong, careless people to despise not justice, mercy, and truth. . . . Would America have been America without her Negro people?"

At forums devoted to the issue of cultural diversity, Reagon noted, people discuss the question of how people grounded in "Western culture," or "American culture," can become more culturally diverse. She suggested that they have missed the point: "America is a Western nation that is brimming with cultures from all over the world." Americans, when they celebrate themselves artistically, should not simply draw from the elite culture of Europe; such an acknowledgment would inevitably alter the debate over cultural diversity.

"Either all of us are the other, or none of us are the other," insisted Reagon. One does not have to search outside the cultural fabric of the United States to find diversity, one only needs "to be honest about what is American."

MULTICULTURAL EDUCATION: WHAT DOES IT MEAN TO INFUSE IT INTO A DISCIPLINE?

CARL A. GRANT
Professor
Department of Curriculum and Instruction
University of Wisconsin
Madison, WI

CHRISTINE E. SLEETER
Associate Professor
Department of Education
University of Wisconsin at Parkside
Kenosha, WI

Despite the resistance of certain sectors of the educational community, the speakers noted, interest in infusing multicultural education throughout the curriculum continues to grow. Unfortunately, many of the educators who are most receptive to the idea of multicultural education do not have a clear understanding of its history, premises, and conceptual bases. Consequently, they incorporate "diversity into their work simplistically, often within a Eurocentric framework."

Grant and Sleeter provided an overview of the history of multicultural education in the United States, including some of the different conceptions and approaches that have predominated in the last twenty-five years. They divided this history into three periods:

1. the late 1960s and early 1970s, when multicultural education began as an offshoot of the civil rights movement;

2. the conservative backlash of the late 1970s and early 1980s, when "diversity" was marginalized within the framework of educational "deficiency" and "at risk" students;

3. the late 1980s and early 1990s, when demographic shifts placed multicultural education at the center of pedagogical debates and when the intellectual advances of ethnic and women's studies provided the field with a broader conceptual basis.

The civil rights movement of the 1960s and early 1970s spawned several related movements to make education equal across racial boundaries and accessible to all students. Desegregation, bilingual education, special needs education, gender equity, and mainstreaming removed barriers for a wide range of students within the school system. Grant and Sleeter located the genesis of multicultural education solidly within this broader movement. They noted that its initial goal was to reflect the history, culture, and contributions of traditionally disenfranchised people in the general curriculum. Originally seen as a strategy for combating racism, multiculturalism later

expanded to encompass sexism, classism, and disability.

In those early days of multicultural education, eliminating bias in textbooks and instructional materials was the primary activity that was undertaken. School districts in large urban areas organized curriculum committees and formed human relations departments to help sensitize teachers to racial stereotypes and to deal with the social and political fallout from busing and desegregation. At the same time, ethnic and women's studies programs were instituted at the undergraduate and graduate levels, promoting research that further enhanced the theoretical and scholarly sophistication of the field.

In the late 1960s and early 1970s, multicultural education received support when the major educational associations organized task forces and delineated their positions on the issue. Other developments that reinforced multicultural education included the growth of the women's movement and the passage of Title IX legislation that barred sex discrimination in academic and athletic programs, not to mention the passage of the Bilingual Education Act in 1968.

As multicultural education flourished at the margins of the educational community, a "White, male, backlash" was brewing in the mainstream, fueled by an expanding conservative agenda. By the early 1980s, the focus of educational debate was the faltering international status of the United States in terms of trade, educational achievement, and economic productivity. With the publication of *A Nation at Risk* (National Commission on Excellence in Education) in 1983, the focus of reform efforts shifted from "equity" to "excellence," with a particular emphasis on a return to "basics," including increased testing and higher standards for both students and teachers. Consequently, students of color, poor students, and those whose first language was not English were characterized as being "at risk" of failure. Furthermore, funding for programs supporting multicultural education was eliminated, and bilingual education came under attack at the federal level.

In the mid-eighties, changing demographics and international economic competition pushed corporations into multicultural education, which they often called "human relations training." By 1985, it became apparent that the racial composition of the United States was undergoing a major shift and that people of color would outnumber White Americans sometime in the twenty-first century. The "browning of America" is now pushing multicultural education to the fore once again.

Another factor that has stimulated the spread of multicultural approaches to education has been the effect of economic and social changes on the school-age population. Increas-

ing numbers of students live in poverty and are born into single-parent households headed by teenaged mothers.

Despite renewed interest in multicultural education, much work remains to be done on the general curriculum and on textbooks in particular. The Study Committee for Asian and Pacific Islander Concerns of the National Education Association (NEA) has submitted a report outlining specific concerns typical of those expressed by other members: the lack of a safe, positive, learning environment; materials and methods that are inappropriate for students from preliterate societies; the lack of understanding of Asian and Pacific Island culture and traditions on the part of teachers and administrators; the threat to minority culture from "English only" legislation; the lack of Asian and Pacific Islanders in leadership positions within the NEA.

Despite the perceived need for multicultural education, many educators have approached it with ambivalence. Additionally, many of those who embrace the concept tend to oversimplify or underestimate the degree of change called for and are content with merely injecting a few folk customs and ethnic heroes into the curriculum.

Nor has multicultural education had much impact on college campuses, where, despite the appearance of integration, groups are often frag-

mented along racial, ethnic, or other lines. Some state universities, such as Florida State, Minnesota, and Wisconsin, however, have instituted course requirements in ethnic or women's studies as a way of fostering cultural sensitivity. Women's Studies, African-American Studies, and Hispanic Studies departments have added immeasurably to the theoretical discourse on race, gender, and the canon, while students themselves have become "participant observers" in the increasingly rancorous debate over the canon and curriculum reform. Grant and Sleeter observed that the training of elementary and secondary teachers requires three to four years of course work in the liberal arts. Consequently, a teacher's future disposition toward multicultural education is often shaped by the degree to which it is integrated into the academic disciplines at his or her particular institution.

Grant and Sleeter identified the five most prevalent approaches to education across cultures:

1. teaching the exceptional and culturally different;

2. human relations;

3. single group studies;

4. multicultural education; and

5. multicultural and social reconstructionist.

The first approach helps students to achieve within and assimilate into an existing social structure. Strategies to bridge the gap between students' backgrounds and the dominant culture include matching instruction to different learning styles, using culturally relevant materials, and bilingual education. Advocates of this approach are likely to focus on a particular group, such as inner-city students, non-English speakers, or special education students. They generally support the existing norms, emphases, and structures offered by the dominant culture. However, while many teachers new to multicultural education are attracted to this approach, the emphasis on adaptation to dominant cultural norms leaves those norms unchallenged.

The human relations approach aims at fostering effective relations among individuals from diverse racial and cultural groups while increasing self-esteem and social harmony. Much of what schools do in the name of multicultural education falls into this category, with its emphasis on heritage weeks, festivals, and cultural awareness events. This approach deconstructs stereotypes and boosts ethnic awareness and cultural sensitivity in a way that fits particularly well with a European-American conception of ethnicity, which is primarily a voluntary embrace of family history expressed through celebrations and food. Because it is manifested through ancillary activities, the human relations approach has little effect on curriculum development. Additionally, in its striving for harmony, this approach has a tendency to gloss over deep and serious conflicts between groups.

In contrast to these two approaches, the single-group studies and multicultural and social reconstruction approaches raise major questions about the prevailing social order and how knowledge is defined. In single-group studies, oppressed groups address issues from their own vantage point, reconceptualizing entire fields of study based on the experience and perspective of a previously marginalized group. Afrocentric, feminist, and Hispanic literary theorists have challenged the traditional European definitions of literature, providing new questions, theories, and frameworks for organizing knowledge and conducting research. Unfortunately, few teachers have the kind of specialized knowledge of nondominant cultures required to teach from these perspectives.

The multicultural approach promotes social equity and pluralism by reconstructing the educational process—in other words, by organizing disciplinary content around the perspectives and knowledge of various racial, ethnic, and gender groups. For example, an art class on the concept of line might feature art produced by Asian-American, African-American, and European-American artists. As a corollary to this approach,

teachers are encouraged to examine how gender or racial bias may be embedded in teaching practices and materials. The multicultural approach builds on students' learning styles and fosters the hiring of diverse staff to ensure that traditional stereotypical roles are not reproduced. The multicultural and social reconstruction approach builds on the previous approaches by encouraging students to analyze inequality and oppression within society and by helping them develop the skills needed to address these problems. The chief goal here is to realize in everyday practice the American ideals of democracy, justice, and equality. Examples of such an approach in an art class would be analyzing the lack of representations of Native-American women in art galleries or examining the tendency of one's own culture to depict religious art from other cultures as "superstitious paraphernalia."

Despite the theoretical advances in multicultural education, most schools are still operating along traditional lines, complying minimally with federal and state equity regulations and explaining away inequality as the product of "deficiencies" within oppressed groups. Native Americans are addressed cursorily around Thanksgiving; African Americans during Black History Month. Meanwhile, in the larger society, competition among diverse groups will continue to intensify due to economic stagnation and decline in the availability of resources, such as decent-paying jobs.

Although demographic changes in the student population mean that teachers will be under more pressure to address multicultural issues in the classroom, the teaching force includes fewer people of color every year. This trend could exacerbate the current tendency toward offering "tourist curricula" in which multicultural education is reduced to merely adding ethnic food and folk customs to the standard curriculum. If authentic multicultural education (which is concerned with forging a truly equal and just society) is to be a goal, then teachers must be given the training, advice, and materials they will need to meet that goal. In this regard, the work of organizations such as the Getty Center can be enormously helpful.

ART EDUCATION FOR CULTURAL DIVERSITY: DEVELOPMENTS IN THE UNITED KINGDOM

RACHEL MASON

Head

Centre of Post-Graduate Teacher Education

De Montfort University

Leicester, England

Before beginning an overview of multicultural education in Great Britain, Rachel Mason called attention to four factors that distinguish the movement there from efforts taking place in other Western nations. First, culturally diverse education was instituted in government policy and practice in the late 1960s and early 1970s, aimed at assimilating children of Black immigrant families into mainstream British society. Second, multicultural education in Britain emphasizes race relations and recognizes racism "not just as a contribution to the underachievement of Black students, but as a debilitating factor in indigenous White students." Third, the rise of a new "ethnic nationalism" is challenging the traditional concept of the British community. Fourth, the Education Reform Act of 1988 has mandated a national curriculum that contains a multicultural cross-curricular dimension. Given the preceding factors, Mason explained, she chose to apply the typology developed by James Banks because of its underlying emphasis on race relations (Banks, 1991, ch. 5).

Regarding content approaches, Banks has theorized four levels of integration for multicultural material. The first is the "contributions" approach where "masterpieces" of non-Western art are singled out and judged by the same criteria used to evaluate Western art. The problem with this approach is that it easily leads to the trivialization of non-Western people and their cultural products, which are viewed only in isolation and in the context of the Western canon.

The second level of content integration is cultural. Here, concepts, techniques, and themes from other cultures are added without altering the basic curriculum. This typically occurs in the form of single courses on minority arts and crafts or minority artist residencies. This approach can serve as a useful first step in restructuring an art curriculum to reflect multicultural content, perspectives, and paradigms. Typically, however, students exposed to this approach continue to view and evaluate non-Western art according to Western art historical criteria.

The third level of content integration involves transformation or a change in the assumptions underlying the mainstream art curriculum. This approach enables students to view concepts, ideas, issues, themes, and problems from culturally diverse perspectives, to formulate new paradigms and definitions of art. To implement this approach, securing access to materials

and resources that provide multiple perspectives on art must become a major preoccupation of teachers.

The fourth level of content integration, "decision-making and social action," includes all of the elements of the other three approaches in combination with a requirement that students address directly a controversial social concept, issue, or problem. The goal of this approach is to teach students decision-making skills and to help them acquire a sense of personal, social, and political effectiveness. To implement this approach, teachers must employ cross-curricular and interdisciplinary models, particularly those drawn from social studies and history. An example of this approach is a unit entitled "Antiracism and Art in Britain and South Africa" that asked students to analyze "the Black struggle for justice and equality" in a comparative framework. Mason agreed with Banks that in actual teaching practice these four content approaches are mixed or blended as teachers move gradually from a contributions approach to a transformative and socially active approach.

One of the goals of multicultural education is to help minority students improve their academic achievement. This can be approached from two opposing philosophical positions. One, the cultural deprivation model, assumes that minority student failure is the result of the student's home environment and that the school must compensate for the deficiencies of that environment. The other, the cultural difference position, holds that the school is responsible for a student's academic failure because it refuses to modify traditional, mainstream school culture in light of the ethnic and racial diversity of the student body. Teachers who embrace the latter approach seek to help minority students by drawing on their cultural strengths and using teaching strategies consistent with their students' learning styles.

Helping minority students develop a more positive self-image and increasing the level of positive racial contact among students should be a key goal of educational and curricular reform. Unfortunately, Mason knew of few White art teachers who employed either of these techniques. Black educators, however, continue to develop strategies for racial awareness and prejudice reduction that merit much greater attention from mainstream art educators. Mason cited a unit entitled "Black People in Art" that asked students to analyze mass media images of Third World peoples in order to establish that images are never neutral, but always communicate a point of view. This analysis is augmented with a section on racism in historical context and a survey of artworks in British galleries and museums. Students are

encouraged to inquire into the "underlying class interests" that condition representations of minorities and the "overall connections between race, gender, and class."

Mason was convinced that authentic multicultural art education necessitated a "transformative" approach to curricula for all pupils, including an "antiracist" component for mainstream White students. She added that the social action approach may be more suitable as a component of an interdisciplinary program in citizenship. Regardless of the approach, however, Mason insisted that students must be directed to artworks of outstanding quality, whatever their cultural context, so that they can develop an appreciation of "excellence."

Mason noted that her own "unrepentant" preference was for an internationalist or global, as opposed to a cultural nationalist, approach to multicultural art education. In an internationalist sense, there is a need for art education to come to terms with our postmodern age as it is manifest not just in the subject area itself but in all aspects of life (both positive and negative factors) and to directly confront Western aspirations to global dominance.

"SPECIES-CENTRISM" AND CULTURAL DIVERSITY IN THE ARTS

ELLEN DISSANAYAKE

Independent Scholar and Visiting
Research Fellow
Institute for Advanced Studies
University of Edinburgh
Edinburgh, Scotland

In order to understand art properly, according to Ellen Dissanayake, it is important to view its manifestations historically and cross-culturally. Using this broad-based approach, which she termed "species-centric," we can appreciate that the arts are common to humans of all times and places. In Dissanayake's opinion, as an approach to understanding art's place in society, "multiculturalism is not enough, and is doomed to divisiveness and fragmentation without the unifying pull of species-centrism."

The speaker's development of the idea of species-centrism derived from her own experience. Married to a Sri Lankan, Dissanayake spent fifteen years in her husband's country, as well as time in Nigeria and Papua New Guinea, and realized that an underlying humanity joins all people, despite their ethnic, religious, gender, and racial differences. Significantly, she spent much of her time abroad amongst people who still followed simpler and more natural life-styles, less devoted to the competition, consumption, and intellectualizing that characterize life in the West.

As a result, Dissanayake became aware that, as Americans "there are so many fundamental things that we ignore . . . and so many trivial things that we consider essential."

In describing species-centrism, Dissanayake noted that humans are an animal species with biologically endowed tendencies to behave culturally—to learn a language, make and use tools, and impose conceptual order. She suggested that such cultural practices, including the arts, are means of "satisfying fundamental human biological propensities or needs characteristic of our species." Furthermore, much "domesticated" cultural behavior, including the evolution of racial, national, and religious groups, is relatively recent in the history of hominids, who are themselves a late development in biological evolution.

In regard to the arts, Dissanayake noted that few biologists have asserted that humans are innately artistic. Yet children readily engage in the arts at an early age, and all societies, from premodern to modern, make and enjoy the arts in some form. However, scholars rarely ask why humans make art or where the art-making impulse originates. She suggested that this universal impetus to make art is related to other universal human appetites or propensities, such as the attraction to the extraordinary and unusual. In its most fundamental sense, Dissanayake asserted, art is the activity of *making things special:*

decorating the body or objects, performing exaggerated or expressive movements, or magnifying the natural voice into song. This tendency to "make special" the things one cares about helps explain why the arts have so often been tied to religious, magical, and spiritual practices, and to important occasions like birth, marriage, the harvest, and death.

In order to examine the claim of multiculturalists that conventional notions of art are inadequate, Dissanayake proposed using the perspective of species-centrism to compare the manifestations of the arts in premodern and modern societies. Her comparisons addressed four aspects of

1. art,

2. the artist,

3. the response of the audience or participants;

4. the function of art in society.

In premodern societies the arts tend to be immediate and performative and are often not separable into media. For example, religious ceremonies involve visual display, gestures and dance, poetic language, and musical accompaniment all used together. The artwork is thus the activity itself, rather than an object. In such cases making art is rarely a specialized vocation but is undertaken by all participants.

Tradition dictates certain responses to the arts—awe, wonder, pleasure, transcendence—all of which reaffirm the values of the society and unify the community. In fact, in such societies, art functions to reinforce group solidarity and to fortify communal beliefs about the order of the world and the purpose of life.

As the result of a number of complex and interrelated historical and social forces, including capitalism, individualism, secularism, and technology, art in modern society has become less a form of social practice and more a form of ideology. The idea of art has been narrowed and elevated to mean specific types of "fine art," as opposed to crafts or popular forms. "Art" is generally assumed to refer to specific objects or works—individual paintings, sonatas, poems, dances—produced by specialists known as "artists." Although this definition of art is unprecedented in human history, and virtually unknown in hunter-gatherer, pastoralist, or agricultural societies, it has been the preeminent meaning of art in the West since the early nineteenth century.

As a consequence of these changes, the modern response to works of art is generally private. For certain individuals, it may be a source of self-transcendence, or of a sense of union with

a larger whole. Yet, for Dissanayake, modern art is intrinsically elite and exclusive, incapable of unifying the social group because it requires education and a cultivated sensibility to be understood.

Dissanayake quoted Archibald MacLeish's famous line "a poem should not mean but be" as an illustration of the modern tendency for art to eschew both purpose and meaning and to be "removed from life." At most it has become a commodity to be bought and sold or an object to be displayed and perceived "aesthetically."

It is intriguing, noted Dissanayake, that artworks and forms emphasized by multiculturalists today have characteristics that could be described as premodern—they are immediate, performative, accessible, and concerned with shared values. However, implementing multicultural art education in a Western context will hardly be a simple matter. In contrast to premodern societies, modern society must address many different cultures and belief systems. In this context, the Western "humanities" can be viewed as one system among many that humans have devised to explain their world.

"Eskimos are not better than Mbuti pygmies, or Italians better than Greeks," explained Dissanayake, although we can ask whether one cultural system serves "universal human species needs" better than another. But emphasizing one society's arts as intrinsically superior to another's on some dogmatic scale of values will only generate strife. It is more important for representatives of each culture "to realize . . . that species-centrism embraces and precedes culture-centrism," for only within a larger awareness of our common needs and heritage can we constructively appreciate the differences in individual cultures. However, Dissanayake is convinced that the arts, if properly introduced, can serve as an ideal avenue for "harmonizing" the competing claims of diverse and warring cultures.

Dissanayake concluded with a call for an arts education, in schools, homes, and communities, that teaches the arts without romanticism or condescension "not only as expressions of . . . unique individual cultures but as ways that cultures answer to more common underlying human needs"—that is, as testimonies of a common humanity. Additionally, the arts can help people in modern cultures, whose lives tend to be fragmented, competitive, and materialistic, to recognize and articulate what is special and valuable in their day-to-day existence.

DBAE and Cultural Diversity:
Three Perspectives

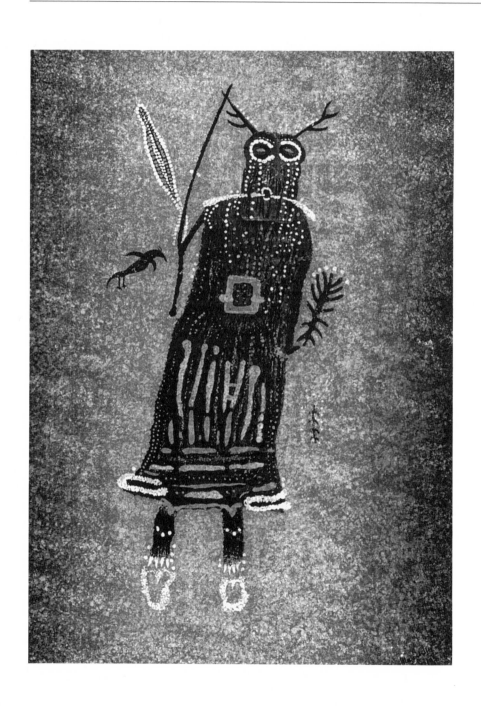

Painting
Fremont Culture
Southeastern Utah
Date unknown

INTRODUCTION

CLAUDINE K. BROWN
Deputy Assistant Secretary for the Arts
and Humanities
Smithsonian Institute
Washington, D.C.

Claudine Brown welcomed the audience to the second day of the Third Issues Seminar and noted that this was a special gathering. While there have been many conferences on the topic of cultural diversity, few have encouraged the kinds of dialogue and exchange that have been stimulated here.

The various participants in this conference have been drawn by the opportunity to discuss discipline-based art education (DBAE) and cultural diversity because they want to strengthen their work and clarify their common purposes. Their backgrounds are broad and varied, and they include curriculum specialists, theorists, historians, and classroom teachers. They have come together to reexamine assumptions, to reflect on the history of both DBAE and cultural diversity, and to consider the implication of their convergence. They are examining how DBAE's theoretical framework supports its practice and whether that practice demands additional theory. Finally, they are

here to support growth and change and to impart a powerful and cogent voice to a new generation.

Most of those present were teachers in some capacity, observed Brown. But they were also learners, willing to support and encourage collective creativity. She hoped that the discourse generated at the conference would be honest and bold and that every person would depart with a new understanding.

Brown then introduced the morning's speakers. Michael D. Day is chair and professor of art at Brigham Young University. He has served as faculty member and adviser for the Getty Institute for Educators on the Visual Arts and as codirector of the Getty Curriculum Development Institute. Dr. Day is the coeditor of *Discipline-based Art Education: A Curriculum Sampler* and the coauthor of *Children and Their Art,* a popular college text.

F. Graeme Chalmers is professor of art education at the University of British Columbia in Vancouver and the author of nearly ninety publications in the field of art education. He is currently the chief examiner in art/ design for the International Baccalaureate Organization and has served as vice president of the International Society for Education through Art.

Frances E. Thurber is assistant professor of art education at the University of Nebraska at Omaha, where she also serves on the women's studies faculty and on university committees addressing issues of cultural diversity. She is president-elect of the Nebraska Art Teacher's Association and is at work on an elementary curriculum guide for the Nebraska Department of Education. Dr. Thurber is currently the coordinator of a Getty-funded University of Nebraska project devoted to researching DBAE methodology.

CULTURAL DIVERSITY AND DISCIPLINE-BASED ART EDUCATION

MICHAEL D. DAY

Chair and Professor of Art

Harris Fine Arts Center

Brigham Young University

Provo, UT

Michael Day began his presentation by noting his amazement regarding published assertions that DBAE is an "elitist, Eurocentric, formalist . . . approach to art education." On the contrary, he insisted, DBAE is an excellent platform for teaching "a broad range of the visual arts, including folk, applied, and fine arts from Western and non-Western cultures, from ancient to contemporary times." Day cited the article he authored with Gilbert Clark and Dwaine Greer, "Discipline-based Art Education: Becoming Students of Art" (Clark, Day, Greer, 1987) which is the most complete explication of DBAE, as explicit evidence of this fact.

Examples of art given in the article, Day recalled, included Japanese rock gardens, Bamana antelope headdresses, Egyptian art, Native American art, Japanese block prints, a selection of Western European works, and a number of American works, including magazine illustrations. The nine illustrations, which focused on American artists, included works by Winslow Homer, Mary Cassatt, Alice Neel, and Romare Bearden, and represented male and female artists, and artists of Chinese, African, and Japanese backgrounds.

Responding to the oft-repeated criticism that DBAE favors formalist analysis, Day reported that the article refers repeatedly to social and cultural aspects of art and covers Marxist, psychoanalytic, and feminist analyses. It strongly emphasizes DBAE's mandate to study art in its historical context, including factors such as patronage, economic, scientific, political, and religious influences. "Such is not the portrait of a narrow, elite, formalist approach to art education," asserted Day.

The flexible and dynamic character of DBAE stems from its grounding in disciplines, such as aesthetics and art criticism, that, necessarily, respond to intellectual trends and contemporary movements. Consequently, the enormous vitality and theoretical upheaval within the art world becomes a source of "up-to-date" content for art curricula.

In regard to multiculturalism, Day noted that *The DBAE Handbook* by Stephen Dobbs (1992) specifically recommends that art curricula draw on examples from outside the European canon and from outside the traditional fine arts media. Asian, African, and Latin American art, folk art, ceramics, jewelry, photography, industrial arts, and fashion are only some of the examples cited. DBAE's receptivity to diverse art, Day

asserted, is not external to, but implicit in its overall goal, which is to promote an understanding of the visual arts in all their variety and multiplicity.

After providing some examples of recommended DBAE art activities that used Native American, Japanese, and African objects, Day considered some of the primary reasons for encouraging a culturally diverse study of the visual arts. First, there is the probability that students will gain a broader and deeper understanding of the world in which they live and become better, more tolerant leaders and citizens. Additionally, by studying the arts of their own particular cultural heritage, they will gain a feeling of cultural belonging and self-esteem.

But whatever rationales are espoused, Day maintained, the central goal of DBAE remains the development of students' abilities to understand and appreciate the visual arts. Other outcomes, important as they may be, must be subordinated to this overarching goal. While it is hoped that innovative and multicultural art curricula will develop self-esteem, improve attendance, bolster achievement in other subjects, and foster tolerance, none of these is the primary objective.

Day reminded his audience that, in the final analysis, curriculum content and implemen-

tation are determined by local school districts, often in response to state guidelines. The specific role of art in multicultural education will be determined at the local level in response to local needs. Therefore, it is essential that teachers, principals, parents, students, administrators, and community members be convinced of the intrinsic importance of art to the educational process.

Day believed that the critics who have called DBAE narrow, formalist, or elitist have "lodged their complaint at the wrong window." In his view, a far greater problem is its breadth and depth, which places a high demand on teachers by expecting them to understand all four disciplines and provide integrated, contextual instruction on a wide range of art objects. Given the complexity of presenting diverse objects in a cultural context, teachers will inevitably be asked to address cultural values, practices, and aesthetic forms that are relatively unfamiliar to them.

New evaluation methods are also placing a burden on teachers, noted Day. Rather than simply making assessments based on the quality of student work, teachers must now grade papers, lead philosophical discussions, judge portfolios, and take alternative learning styles into account. Because of these and other difficulties posed by DBAE, teachers will need assistance, including in-service education and

new teaching materials with appropriate background information.

Although DBAE will undoubtedly require extra effort on the part of teachers, Day was convinced that it was worthwhile. Provided with high-quality materials and methods, "teachers and students alike begin to realize that they are teaching and learning 'the real stuff.'" Students exposed to DBAE are "transformed . . . they exhibit qualities associated with educated people." Day concluded that the ultimate "payoff" of DBAE is "the opening of a world for students to which most of their parents have little access and which can enrich their life experience in meaningful ways."

HOW DOES DBAE RESPOND TO CULTURAL DIVERSITY?

F. GRAEME CHALMERS
Professor
Department of Visual and Performing Arts
in Education
University of British Columbia
Vancouver, British Columbia

While Graeme Chalmers does not think that DBAE has been successful in the past in responding to multiculturalism, he is convinced that the potential is there. His conclusions about DBAE's past were drawn from a number of documented studies in the art education literature of the 1980s. However, since the late 1980s there has been an encouraging response on the part of DBAE theorists as evidenced in the Getty Center's *DBAE Handbook* (Dobbs, 1992) and the *Curriculum Sampler* (Alexander and Day, 1991), both of which support culturally diverse curricula built around a wide variety of art traditions. These books, and a number of statements by key figures, such as Harold Williams and Faith Clover, have cemented DBAE's commitment to the principles and practices of multicultural art education.

This does not mean, noted Chalmers, that DBAE educators need do nothing more than promote art education as a unifying element in a fragmented world. It is not enough to cover Ukrainian Easter eggs one week and fold Japanese paper the next: "We must take DBAE beyond formalism and to the realization that art is a powerful force shaping our vision of the world." DBAE's emphasis on inquiry and meaning can carry it beyond the traditional Western paradigms of "masterpieces" and "geniuses," insisted Chalmers. It can communicate the idea that cultural pluralism is a reality; that no racial, cultural, or national group makes art superior to another's; and that every student, regardless of background, is entitled to respect.

We need an approach to art education that *does not* assume that art is fundamentally a means of self-expression or that "pure," "universal" aesthetic principles are of primary importance. We must communicate, also, that it has always been the prerogative of the powerful to limit the cultural, aesthetic, and economic opportunities of other groups.

While DBAE has always been more informed by the humanities than the social sciences, Chalmers suggested that anthropology may offer an important grounding for a culturally diverse approach. In fact, art education might benefit from being modeled after social science education. If so, the study of artists and their socialization, of culturally specific values, and of changing conditions that influence artistic expression could then be carried on more thoroughly.

Chalmers acknowledged that this view differed from the view articulated by Gilbert Clark,

who suggests that DBAE must remain focused on art and its disciplines rather than on society. However, he countered, this may no longer be an issue because art history, criticism, and aesthetics have themselves been adopting social and economic frameworks, as shown by the work of Arthur Danto (1990) and John Berger (1972).

The collapse of connoisseurship and Kantian aesthetics signaled by the "new art history" has opened the way for DBAE to examine the arts as systems of signification that encode the values and ideologies of their time and place. As the Frankfurt School theorists and others have outlined, the meaning of a work depends on the cultural expectations against which it is received. Such a notion has rich implications for teaching art in a culturally diverse world.

The timeless purpose of all art, concluded Chalmers, "is to enhance our sense of being, not only here and now, but in the continuum of time and tradition." Art educators who view art as a process of human action and interaction will give the subject itself greater cultural impact and meaning, which is, after all, the ultimate goal of DBAE: "Therefore, yes, the door is open for DBAE to respond to cultural diversity."

CULTURAL DIVERSITY AND DBAE: THE CHALLENGE OF ONE WORLD AND MULTIPLE VISIONS

FRANCES E. THURBER

Assistant Professor

Department of Art and Art History

University of Nebraska,

Omaha, NE

Frances Thurber proposed to examine, from her experience as an art educator, how DBAE might best respond to the reality of cultural diversity, highlighting theoretical issues and practical models along the way.

At a time when unprecedented political and economic change and rapid technological advancement characterize the affluent mainstream of national life, thousands of marginalized urban and rural children struggle to meet the basic needs of daily existence, unfairly burdened by poverty, racism, and hopelessness. Traditional social organizations, such as the family, are being redefined as one in four households consists of a single person, and 9.5 million households are headed by single females, a third of whom exist below the poverty level. Demographics are also changing as fewer Americans trace their ancestry to Western Europe and more speak a language other than English in their homes.

These, and other statistics on class, income, gender, age, race, ethnicity, or religion reveal that cultural diversity is an American reality that educators must face. For art educators who use a discipline-based approach, the implications of these statistics are tremendous, particularly to researchers who have questioned whether DBAE is capable of recognizing and addressing issues of cultural diversity. "Are multiculturalism and pluralism compatible with the degree of artistic literacy and excellence demanded by DBAE?" asked Thurber.

In answer to this question, Thurber offered a definition of multicultural education suggested by Swartz (1992):

> Multicultural education is an education that uses methodologies and instructional materials that promote equity of information and high standards of academic scholarship in an environment that respects the potential of each student. . . . In short, multicultural education is a restatement of sound educational pedagogy and practice that requires the collective representation of all cultures and groups as significant to the production of knowledge.

Given this perspective, why has DBAE not responded to diversity more fully in the past? Dobbs (1989) suggests that the emphasis on European art in presenting DBAE stems from the training, experiences, and values of professionals in the art disciplines, which in turn have

been shaped by the overwhelming emphasis on European art prevalent in their own schooling, from the kindergarten to the graduate level. Consequently, Thurber proposed, preservice and inservice teacher programs have served as "cultural mediators," perpetuating a Eurocentric perspective. Postsecondary educators, then, have a responsibility to improve the scope and depth of their programs in regard to culturally diverse art.

Thurber noted that the charge that DBAE is inherently Eurocentric at a programmatic level may spring from a misunderstanding of its highly flexible format. Because DBAE does not mandate the objects under consideration, achieving a multicultural approach will depend on how the format is translated into local practice. However, Thurber noted, this still leaves the question of whether DBAE is open to multiculturalism at the conceptual level.

The theoretical foundation of DBAE around the four arts disciplines of studio production, aesthetics, art history, and criticism is not, in Thurber's opinion, inherently incompatible with a culturally inclusive approach. In fact, scholars such as Donald Preziosi have proposed that a new version of the most "conservative" of these disciplines, art history, could be constructed from "the history, theory, and criticism of the multiplicity of cultural processes that might be construed as enframing: an accounting for objects and their

subjects with all that might entail" (Preziosi, 1989). In fact, Thurber was convinced that if DBAE educators did not question the canon, they were essentially ignoring the larger mandate of DBAE.

In a pluralistic approach to DBAE, proposed Thurber, the issue of object selection can be made part of the inquiry process, raising issues of "high" versus "low" art and questions of interpretation, quality, and standards that can only be answered through an examination of cultural assumptions and values.

Art is created as a human response to a particular time and place in history, noted Thurber, and students need to understand the particular values generated by and through artworks, which can be universal or culturally specific. When making a commitment to cultural diversity, teachers must be certain it is not "just an embellishment of our old and comfortable paradigms." Multiculturalism and pluralism "must be consciously embedded in the way we convey the content and inquiry processes of the disciplines."

Regarding the work being done by the DBAE institutes supported by the Getty Center for Education in the Arts, Thurber reported that each regional site was translating its stated commitment to multiculturalism into practice— through the choice of objects, through culturally diverse exhibitions, by incorporating anthropology and sociology into their inquiry of art

objects, and by engaging with culturally diverse artists and community organizations. Thurber offered a brief rundown on some of the activities sponsored by the various regional institutes that fostered and developed multicultural and pluralistic DBAE practice. Key to these activities is paying close attention to the sociocultural composition of the regions themselves.

As an example of these activities, Thurber cited, among others, the Florida Institute for Art Education's development of a program around Faith Ringgold's book and artwork *Tar Beach*. After a committed teacher made contact with the artist, students initiated a dialogue with Ringgold and began exploring their own community through art, poems, and music. As Jessie Lovano-Kerr noted, given the tremendous multicultural resources available in Florida, cultural diversity is "a natural" for their DBAE programs.

The regional institutes' collaborations with local museum programs have served as excellent starting points for fostering a pluralistic and culturally diverse view of art among DBAE practitioners. For example, the "Evenings for Educators" directed by Anne El-Omami at the Cincinnati Museum of Art, make excellent use of the museum's Asian collection in facilitating a contextual understanding of the art of diverse cultures. Another program, at the Joslyn Museum in Omaha, offers "Exploration

Trunks," based on culturally diverse art, to teachers across the state of Nebraska for use in classrooms.

Thurber suggested that educators also focus their energies on efforts to eradicate bias and the trivialization of non-Western cultures from curriculum materials. "Does this resource reflect multiple 'visions,' values, and ideas in a nontrivial way? Does it confront stereotypes, racism, and bias? Is it sensitive to diverse learning styles and can it be adapted to a variety of instructional strategies?" These are some of the questions that teachers must ask before choosing instructional materials.

Thurber is convinced that discipline-based art education possesses the potential to make cultural diversity in the teaching of art a "transformative reality" in the nation's schools. However, the realization of this goal will depend on the personal and professional commitment of each teacher, administrator, museum educator, and art specialist to the creation of a "caring community" in which each student can inscribe his or her personal signature. It will also require collective work and the forging of partnerships among school systems, universities, museums, and cultural institutions at the local and national level. Involvement in professional networks, such as the National Art Education Association women's caucuses, and committees

for lifelong learning and for multiethnic concerns, will help teachers expand their contact with other educators with similar commitments.

Thurber closed with the observation that "respect for diversity begins within." The current cultural climate in the United States and around the world continues to present many new opportunities, but implementation of multicultural curricula is long overdue. The challenge to theorists and practitioners of DBAE is to act on their collective belief that "multiple voices and multiple visions" must be reflected in DBAE content, processes, and structure.

QUESTIONS AND ANSWERS

MODERATOR: Claudine K. Brown

PANELISTS: Michael D. Day, F. Graeme Chalmers, and Frances E. Thurber

Brown: Our panelists will discuss and clarify some of the issues on which they agree and some on which they disagree; they will also address questions submitted by the audience, which I have already reviewed. Some of questions submitted raise the issue of trivialization, not only in how the curriculum is implemented, but in how cultures are addressed. Many of the questions had to do with moving from theory to practice and what models should be used to accomplish this. In the past two days concerns about sacred and religious objects have been raised and how to deal with sacred objects in teaching culturally diverse material. Other questions dealt with how to use art to implement social change.

So far, we have made little or no reference to gender issues, especially to issues of sexual orientation. Several questions asked that these issues be addressed. A number of questions were submitted regarding the diversity of student bodies and how one deals with that diversity in the classroom. Other questions addressed the issues of schools: how they fit within districts, and within their states, and how implementation can take place given those specific circumstances. Some questions dealt with DBAE goals and emphases and whether the notion of DBAE allows for the effective treatment of cultural diversity. There were also questions about bias, as it pertains to each of us, as audiences and constituents. Let us start with comments on any one of those issues.

Day: I would like to start by making a comment about trivialization. Trivialization is a difficult problem because of the time constraints on teaching; it is partly a result of the lack of time. No one is in favor of trivializing cultures, but the fact is, given the pressures of implementation, we are probably going to see more of it.

Thurber: I would like to link the idea of trivialization to the related issue of art education as social action. It is easy to skirt issues of meaning in art, and instead to concentrate on formal qualities. But if you make a leap into the deeper social meanings of an artwork, it is difficult to ignore issues of social action—it is a circular process.

Chalmers: As we look at the hierarchy of implementation in the literature, we have to remember that most attempts start on a trivial level. But we should acknowledge this as a useful beginning and seek to develop this approach until we reach the point of social action. The best way to learn how to do this is by exemplary case study.

Regarding the issue of sexual orientation, I was reading a study by Terry Barrett about a high-

school English teacher who took her class to see the Robert Mapplethorpe show (Barrett and Rab, 1990). She and the students all described their experience in sensitive terms. This seems a useful model for approaching culturally difficult or sensitive material. One suggestion made in the article is that art teachers can learn something about dealing with controversial issues from literature teachers, who may be more experienced with these issues than those of us in the visual arts.

Brown: If you think back to the slides that Rachel [Mason] showed last evening, a lot of the students had happy expressions on their faces and were pleased with the work that they did, although we consider it a form of trivializing cultures. That kind of approach to teaching culturally diverse curriculum is familiar, widespread, and for many people, successful. We now are asking teachers to do the kind of thoughtful work for which there are few resources. How do you help teachers move to a new level of practice and still get the same positive results?

Chalmers: I think you begin with the kind of material that Frances [Thurber] has shown us. We need more opportunities to examine that kind of material because there is a great deal there that can move us to that second-to-last stage.

Thurber: The matrix I presented began as an accident. It evolved out of a social process at the very first summer institute, where teachers were complaining, "I can't get a grip on this material," and "it's so elusive." People wanted to see a graphic depiction of what they were attempting to explore, and out of that process emerged the charts I showed today. I also want to say that the matrix is not intended to constrain. It is only a way of organizing ideas to expand on them and to deepen the experience of art through multiple worlds and multiple voices.

Day: Let me just reinforce that. We had a similar experience with the matrix idea when we were working on the curriculum development project. The matrix, which was published in *DBAE: A Curriculum Sampler* (Alexander and Day, 1991, p. xx), is not intended to direct the teachers' work, but to serve as a check on the ideas that come out of their own experience and practices as teachers, keeping them on track. It is not too difficult for art educators, when dealing with complex and interesting topics in art and philosophy, to move away from teaching art. I have seen teachers move from teaching art to teaching ecology— moving to another subject area entirely. One of the goals is to keep art teachers on track, teaching art, while bringing new and enriching content to the practice.

Chalmers: I think the question for curriculum development is subtly shifting, from "What is art?" to Ellen's [Dissanayake] questions of "What is art for?" or "Why is art?" As long as we keep those two questions at the center of curricula, we can keep the focus on art. And people do not have much trouble developing these questions. As I said in my presentation, I have lots of experience working with student teachers and in teacher education. When student teachers are asked to develop curriculum around those questions, "What is art for?" and "Why is art?" they do not have any difficulty.

Brown: The question, "What is art for?" could lead to a discussion of sacred or religious materials. A lot of Native American and African objects are sacred, and some teachers feel that they would have difficulty showing this work in their school districts. Can you make some comments on how we should deal with sacred material? This also raises the issue of trivialization as well: How should we put it in context, how should we interpret it, or should we not interpret it at all?

Day: Because I showed the Nkisi n'kondi oath taker figure, which is a sacred object, let me respond. Ninety percent of all art that has ever been created has sacred meaning to those who made it. Take Egyptian art, most of African or Native American art, and all of the art from the

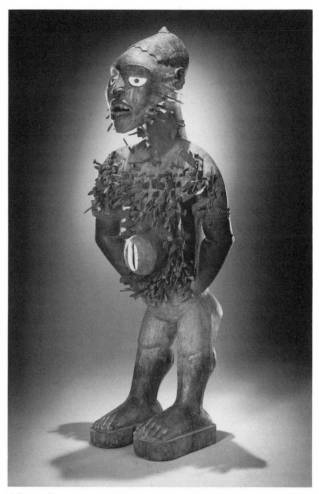

Nkisi n'kondi oath taker (nail figure), The Detroit Institute of Arts, Founder Society Purchase.

Christian eras in Europe much of the art made throughout history has some religious value for the people that created it. So how can we have a curriculum if we ignore all of that? I do not think we could have a rich curriculum if we eliminated all art with religious significance, and I do not

think we should. With the Nkisi n'kondi figure, the relationship of the function of the object to the lives of the people is revealing and enlightening, and it enables us to compare the legal functions that figure fulfills in its society with similar functions in our own culture. Divorce was the example I used, but this figure was used for all kinds of civil and criminal cases. When you compare this to the complicated and confrontational way that legal problems are handled in this society, it raises some very interesting issues.

A number of issues have been raised concerning the use of religious objects and their placement in a museum. We all know about the Zuni people, who have won the right to return some of their objects to the appropriate places in their society. There are other examples of items that are being returned from museums. Regarding DBAE, the approach that I would use is to raise the issue openly with the students. The Nkisi n'kondi oath taker figure that I showed is in the Detroit Institute of Arts, where it is on display. The question of whether it ought to be there, along with other questions, such as whether a person from a Western culture can appreciate an object that was created for a specific cultural purpose as a work of art, should be raised. Can we apply Western aesthetic criteria to those objects? These are interesting questions and make art lessons enriching and enlightening for students.

Chalmers: Of course, when we move discipline-based art education beyond formalism, beyond the visual, we will be getting into these sorts of problems. How does a Jewish scholar study Medieval or Renaissance Christian art? There are many such scholars, and they begin by studying sources. They read the documents from the Council of Trent, they look at the work in context to get a sense of how it was interpreted in its time. We have to change our definition of who the experts are. DBAE has been predicated, somewhat, on the notion that there are four types of experts: in aesthetics, criticism, studio art, and art history. We are going to have to redefine those experts as being people who come from the culture under consideration.

My accent betrays the fact that I am originally from New Zealand. If any of you saw the *Te Maori* show you might be aware that it was "sung" in, in a very significant way. It was seen by the Maori community as an opportunity to share their culture with a wider audience. Certainly, that was a political decision, and there were other factors embedded in that act. But I think we need to move in the direction of redefining the notion of "expert" and the idea of "ownership" so that they refer to people from other cultures, and not simply to academics who publish in scholarly journals.

Thurber: I was recently at a seminar that included museum personnel who were dealing with the problem of a "sacred pole" that had recently been returned to the Omaha people. They were discussing how they should display this sacred pole—not only how the pole could be best shown in a new setting, but how it could be returned to some context. Although this pole now belongs to a culture residing in Nebraska, the entire adult population of the Omaha people has never had the pole as part of their cultural experience. The problem was not simply one of showing the pole to the public so they could understand it, but one of reintroducing the object to its own indigenous culture, which it had long been separated from for political and social reasons. I thought that this would be an interesting classroom discussion for the children of Nebraska. We must allow these ideas to become as much a part of us as the ideas that we were raised with. If we do not, the discussion over multiculturalism will become rhetoric.

Brown: We have talked about sharing traditions with people outside of, as well as within, our own culture. About a month ago, I did a television program that included museum professionals from different parts of Africa. One of the questions raised was "Cultural diversity for whom?" I began to give an answer regarding how we look at cultural diversity in the United States, and someone said, "That has nothing to do with what

I'd like to know. Your museums contain objects that pertain to my heritage and my culture, items that I have never seen, and my children have never seen, and my grandparents may have never seen. At what point do we get access to them?" This was not a question about repatriation, just the wish of people to see their own cultural legacy in their own countries so they can understand their own cultural continuum. Can you speak of our responsibility to African Americans, as opposed to our responsibility to Africans, Asian Americans, Asians, Hispanic Americans, Mexicans, and Puerto Ricans? There have been assumptions that all African Americans want to know about Africa or that all Hispanic Americans are interested in Mexico, but our experience has shown that this is not the case. Some of the ways that we formulate the questions may not be the ways that our audiences wish to receive information.

Thurber: A general look at the available literature on curricula for cultural diversity shows that there is no clear understanding of the differences between specific cultures and their related subcultures in the United States. African-American culture is not the same as African culture, but this distinction is not clearly recognized in the literature on curricula, nor is the contemporarity of various cultures. For example, the Omaha culture still exists today and many people live in

their culture. However, their artwork today does not look like their artwork fifty years ago. We have to educate teachers to be more sensitive to this critical subtlety.

Chalmers: I think we will not be able to deal with the art of African Americans, or Chinese Canadians, until we broaden our definition of what art is and are willing to embrace the popular and folk arts. I find, even in Vancouver, that I have to go to a special gallery to see the art of Native Canadians and another gallery to see the art of Chinese Canadians. Only now are we beginning to bring their art into the mainstream.

Day: I think all of contemporary art is "under-understood." We do not understand the art of our own time, which includes the art of all different groups, not just ethnic groups. Even less understood by our students and by the general population is the effect of the applied arts on their lives. The graphic arts, for example, influence many of our decisions, including the election of presidents. Given their tremendous importance, the graphic arts are certainly worthy of inclusion in a broad program of art education. Having an initial idea about the broad function of art in society can give students a handle, on not only how people of other times and places have used art, but on how art is used in their own culture, in their own lives.

Brown: We have reached a point where we can entertain some of the questions the audience has posed. We have put together certain questions in categories. They may encompass some of your thinking, although not in the exact wording you used. We will try to cover the issues you have raised.

Q: Each speaker referred to the trivial art projects, relating to other cultures, that were developed and implemented by classroom and art teachers. These were referred to as "first-level projects." What are examples of productions that would be more meaningful?

A: (Chalmers) I will use the example of the totem pole made out of toilet paper rolls. I think the way to turn that sort of project into a meaningful activity would be to study the totem poles of the Northwest people and broaden that study by asking "Why were these poles made? What is the reason for their being? What is that art for? Why is it art?" Next, look at work from other cultures that fulfilled the same need. The University of British Columbia's Museum of Anthropology did a wonderful show a few years ago called *"Homo ektachromo,"* in which students took slides of contemporary Canadian cultural pieces and compared and contrasted the objects with objects from the museum's collection. One might have also juxtaposed a series of slides of tombstones from local

cemeteries and related them to funerary objects. Another possibility would be to have slides of ten-tier birthday or wedding cakes and compare them with other celebratory objects. From that study of totem poles might come an assignment in which students produced something that had cultural meaning for them, but also a functional purpose.

Q: Michael Day made reference to children creating symbols in their own artwork after learning about an American Indian war shield. He hoped that the symbols they created would be better than the body symbols Rachel [Mason] showed yesterday, which he described as the "wrong" type of example. Why would children who had experienced this curriculum do anything different? At what age are children able to understand the concept of symbols?

A: (Day) In studying children's artistic development, we find they begin very early to create a symbol system of their own; by age eight they have completed that process. They also appropriate symbols they find around them and use them in their drawings. The lesson involving the Cheyenne shield is only one example of the use of symbols in art. Other examples could be drawn from Renaissance painting or from the works of virtually any other culture. In this particular unit students examine the idea of symbols cross-culturally. They look at the sources of sym-

bols, such as the fact that the use of color can be symbolic when used by different peoples. Students also understand that symbols refer to things that are of great value to those who create the art. The next step in the unit is for the child to assess the values in their own life, including those things that they would like to symbolize in their work, and to encourage the child to use symbols to embody those values.

Q: Whatever consensus we come to about DBAE and diversity, in the end it is irrelevant. What matters is what happens in the classroom. We may agree that DBAE is not Western and formalist, but classroom teachers continue to merely scan van Gogh. How can we achieve real change in the trenches? Whatever we have done so far does not seem to be working.

A: (Day) What we have done so far *is* working. I find lots of examples of change in my travels around the country, and I have found many positive things happening. But I agree with the thrust of the question. It is difficult to move from a highly theoretical discussion to actual, everyday, classroom practice with thirty-five kids coming in every forty-five minutes, hour after hour. That is the reality. The trivial examples are, too often, the norm. There is a tremendous market for simplistic materials, especially in the elementary schools, where classroom teachers are still predominantly in charge of art instruction.

Q: There are a number of questions that deal with choices and who makes them. This is a long one, but one that covers most of the bases: If we can teach all cultures and do it well in the limited time of the school year, which cultures, and which artworks, will we emphasize? Will these decisions depend on the individual populations present in the classroom in any given year? Who will make the decisions—administrators, teachers, parents? Will these limitations be seen as racial prejudice or elitism? Why don't we start with the time factor: What can you do in a given year?

A: (Thurber) These issues require some local solutions. The answers are not going to be the same, state to state or district to district. We really have to ask that everyone who is involved in that educational context participates; this includes families, communities, teachers, children, administrators, local art institutions, and artists. You have to look at what is available and make choices on that basis. It is not necessarily valuable, or even possible, to touch on every possible culture. Perhaps approaching curricula with the idea of becoming deeply immersed in a few topics that are important in a local context is a better approach.

A: (Chalmers) I have a small problem with Frances's answer because it raises the issue of what one does in a culturally homogeneous society. It seems to me that those people need multi-

cultural education even more than those in diverse societies. We need to ask those big questions of the curriculum: "What is art for?" and "Why is art?" Then we can choose the specific cultures to explore on a local basis. Yes, everyone should be involved, and yes, it will be a political decision. But those big questions are important everywhere. I think it is wrong to start with the question "What cultures shall we teach?" That should be the second question.

A: (Day) The above question also raises the issues involved in curriculum development in a community, whether the curriculum is adopted from the outside or developed internally. These are the kinds of questions asked in a good curriculum development process and the reason why, in the discipline-based approach, we advocate having some kind of regular curriculum. You know you cannot do everything in one year. You need to use a curriculum from preschool to high school to provide all the things we believe children should be learning.

Q: If the desired outcome of a multicultural art education unit is students who use their art knowledge to be social change agents in society, who selects the change/action that students should undertake? Is an aesthetic focus on political and social reform just as limiting as an aesthetic focus on formalism? How would the outcome of such a program be evaluated? If stu-

dents took social action that put them in jail, would they get "A's?" Would students fail if they did not transfer their knowledge and skills to social action?

A: (Chalmers) This is a very real question and raises some significant issues. I think students are going to have to choose their own focus themselves. Art education began dealing with these issues a number of years ago, when Vincent Lanier wrote "The Teaching of Art as Social Revolution" (1969), but it did not go anywhere. I suspect it did not go anywhere because it is such a controversial issue. I do not know the answer. I think those of us concerned with art education will have to sit down and thrash out these issues. But I also think we will have to look to areas of the school in which these kinds of change are already beginning, in writing classes, for example. How do writing and literature teachers handle it? How do they address writing as a means of social change?

Some of us have seen something like the AIDS Quilt project, which was a project intended to change social attitudes, as well as to commemorate and memorialize. Many of us might think that the work was, in aesthetic terms, awful. In fact, I was repulsed by the appearance of some of the quilts, but I have never been so moved. We need to deal with the dichotomy between aesthetic power and social or emotional power. We

need to develop criteria that can evaluate success in a broader context.

Q: As schools and districts lose funding for professional development and training time, what can be done to further DBAE and multicultural education efforts through distance learning, teleconferences, and other uses of technology? Opportunities for in-service education are shrinking.

A: (Thurber) Last year, Nebraska Educational Television, with a consortium of nineteen states, produced two interactive video conferences dealing with issues of DBAE. These were after-school, in-service programs for any school district that had the equipment to receive it. Having experienced that, I feel it has great potential, although it is very different from dealing with a live audience and is thus slightly disconcerting. However, as with any new technology, it becomes easier as we become more familiar with it. I see this as a great opportunity to work with teachers on a global scale.

Q: Our students from non-Western backgrounds are often as ignorant of their family's heritage as are Caucasian youngsters. They may not be eager to learn more about their backgrounds, choosing instead to assimilate into the current U.S. popular culture. How does multicultural education

relate to the rejection of their heritage in favor of pop culture?

A: (Day) I would ask, "What is heritage?" I often show slides to my elementary art education class, which includes college students from across the country. I can show them images drawn from popular culture, anything from Mickey Mouse to Orville Redenbacher, and they will know all of the slides. There is no problem in getting students to recognize popular culture. The problem is in getting them to recognize something more serious; the task of a good art curriculum is to engage students personally. Showing objects such as the Nkisi n'kondi oath taker is one way to show them something serious that also engages them in questions and discussions about the functions and purposes of art in their own popular culture.

Q: Along with cultural diversity, what about the learning styles of individual students that might be culturally based? How can teachers learn about, and prepare for, the learning needs of these individuals?

A: (Chalmers) This is certainly something that needs to be dealt with. There are many articles on learning styles and cultures. We need to come to grips with this material and understand what it means for art learning. Nearly all of the general texts on multicultural education contain chapters on learning styles. We must remember to avoid making broad generalizations and applying them to members of particular cultures. We have to remember that we all live in many cultures. You cannot define culture strictly on the basis of ethnicity. You must consider economics, location, religion, and many other factors. This is a complex task, and while June McFee has made a start, it needs to be picked up by the whole field.

A: (Day) One issue that arises is what a teacher should do when he or she knows the learning style of each of thirty or more students. How does the teacher deal with all of these learning styles? One benefit of the discipline-based approach is that it engages a wide range of learning activities and addresses multiple learning styles. We can accommodate different learning styles, even if we have not identified them exactly.

A: (Thurber) Something I would like us to think about is that good DBAE instruction should include a dose of collaborative and active learning along with reflective thinking. We can reach most students if there is a balance between these two.

Q: In a day and time when art education programs have been sadly left out of the national education goals, when budget cuts and site-based management reforms have hurt many art education programs, and when only 58 percent, or fewer, of our nation's schools have elementary art teachers, how much more emphasis do you feel

that DBAE, the NEA, and other programs fighting for the existence of art education, should place on cultural diversity issues?

A: (Chalmers) A lot, because culture develops through the arts. People in general multicultural education are increasingly realizing how central the arts are to their work. National agendas are not dropping multicultural education. This issue gives those of us involved in art education a tremendous opportunity to rebuild our field by making art education a central part of cultural survival. We should not soft-pedal on this issue—it could be, in fact, our savior.

How Have Issues of Cultural Diversity Affected Practices in History, Aesthetics, Criticism, and Art Making?

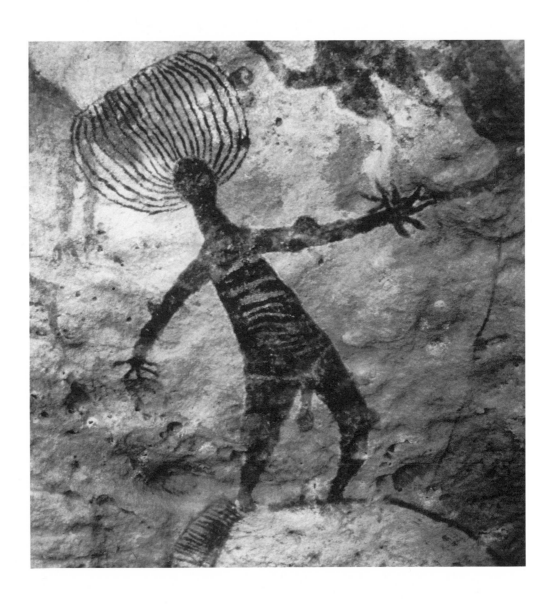

Painting
Northern Australia
Date unknown

INTRODUCTION

PETER PENNEKAMP
Vice President for Cultural Programs
National Public Radio
Washington, D.C.

Peter Pennekamp began the session by remarking that it was an honor for him to be present at this conference. He reminded the audience members that the issues they are addressing are also being faced by all other cultural fields. In many ways, he commented, this group is further along than other fields in dealing with what may be the most important cultural issue of our era.

Four distinguished speakers have been assembled to address the question: How have issues of cultural diversity affected practices in art history, aesthetics, criticism, and art making? Alan Wallach is an active public lecturer and writer on art history and American studies, and is the Ralph H. Wark Professor of Fine Art at the College of William and Mary. His articles have appeared in *Art History, Marxist Perspectives, Art Forum, Art in America, The American Quarterly, The Chronicle of Higher Education,* and others. He has twice been a senior postdoctoral fellow at the National Museum of American Art.

Marcia Eaton is Professor of Philosophy at the University of Minnesota where she teaches aesthetics, philosophy of criticism, ethics, and introductory philosophy. She is the author of *Art and Non-Art: Reflections on an Orange Crate and a Moosecall* (1983), among other works. Dr. Eaton has lectured widely and has been a resident scholar at the Rockefeller Foundation's study center in Italy.

Robert Storr is curator in the Department of Painting and Sculpture at the Museum of Modern Art as well as an artist and critic. His exhibitions include "Dislocations," which included installations by Chris Burden, Adrian Piper, and others; "The Devil on the Stairs: Looking Back on the Eighties"; and "Susan Rothenberg: Fifteen Years, A Survey." Mr. Storr is an author, catalog essayist, and contributing editor to *Art in America,* where his articles on individual artists, public art, and the global art community have appeared since 1982.

After receiving an M.A. in Arts Education from the Rhode Island School of Design, Alfred Quiroz earned an M.F.A. at the University of Arizona. An award-winning artist, he has exhibited widely throughout the United States. Mr. Quiroz has founded two art galleries, taught at two high schools, and worked for two state arts councils. His awards include a National Endowment for the Arts grant and an American Council for the Arts Visual Arts fellowship.

REVISIONIST ART HISTORY AND
THE CHALLENGE OF CULTURAL DIVERSITY

ALAN WALLACH
Professor of Fine Art
College of William and Mary
Williamsburg, VA

In order to demonstrate the confluence of revisionist art history and the goals of cultural diversity, Alan Wallach cited a "miniblockbuster" exhibition mounted in 1992 by the National Gallery, "John Singer Sargent's *El Jaleo*." The painting, a theatrical portrayal of a flamenco dancer performing with a group of Gypsy musicians, was supported by its numerous preparatory drawings and sketches, extensive wall texts, a color brochure, a brief commentary on "the allure of Spain," and an exhibition history of the painting since its first appearance at the Paris Salon of 1882.

This show was widely praised in the local press. Yet, when considered from a revisionist and culturally diverse perspective, the exhibition raises serious questions about museum practice, audiences, identity, and "otherness." What type of audience, for example, was assumed by, or inscribed in, the exhibition? Clearly, the materials presumed that the audience was minimally schooled in Western art and would be able to position Sargent as a "quasi-Impressionist," working in the painterly tradition of Gainsborough,

Velázquez, and Hals. Additionally, the exhibition assumed that its audience was comfortable with an art historical presentation structured around the "masterpiece," or a work created by a solitary genius, so that the sketches, drawings, and other evidence of the creative process are worthy of close study.

The Eurocentrism of the exhibit was evident in more than the use of constructions such as "genius," and "masterpiece," however. A clear bias was also immanent in the celebration of a Western artist's depiction of a mystical and romantic Spain—a site of the "alluring," "evocative," and "exotic," to use words from the wall texts and brochure. While Spain is itself part of Europe, Wallach noted that the exhibition material uncritically cited Alexandre Dumas's comment that "Africa begins on the other side of the Pyrenees," reinforcing its non-Western and "exotic" character.

While it could be argued that the brochure was simply reproducing the attitudes held by Sargent and the Parisian haute bourgeoisie of the 1880s, it appears, remarkably, to be an attitude shared by today's official culture, in which the idea of "romantically distant" Spain is ingrained. Rather than critically interrogating the cultural myths invoked by Sargent, which Wallach believed to be the duty of an intellectually

El Jaleo, *John Singer Sargent, Isabella Stewart Gardner Museum, Boston.*

responsible art history, the National Gallery simply reinforced them.

The fact that the museum completely ignored the work of Edward Said and other scholars who have analyzed Western portrayals of the exotic is not due to careless scholarship, asserted Wallach. It signals something more deliberate and systematic. We might, for example, ask why a naive celebration of the exotic was considered appropriate for the National Gallery, "when the majority of this nation's inhabitants trace their family lines to the far side of one or another Pyrenees." The answer to that question

goes beyond a simple contest between traditional and revisionist art history and must be sought in the political and historical circumstances in which they are practiced.

Twenty-five years ago, the practice of art history consisted primarily of connoisseurship, or the ability to identify and date works of art, formal analysis, and iconography, Panofsky's system of reading meaning in visual images. Underlying these methodological approaches were certain assumptions: Art was the product of (male) genius and Western art—derived from the classical tradition flowing through Greece, Rome, and

the Italian Renaissance—should be the primary focus of art historical inquiry.

The political struggles of the sixties led to persistent demands for greater institutional recognition of cultural diversity and alternative viewpoints, Wallach recounted. At a time when every field in the humanities underwent a period of crisis and self-examination, art history began to grapple with new methodologies, such as feminism, Marxism, semiotics, and deconstruction. This critical shift occurred after a long period of resisting even the most elemental discussions of theory. Today, however, new theoretical tendencies are often incorrectly and indiscriminately lumped together under the heading of "revisionist" art history.

Wallach reported that revisionism "hit a smug discipline like a thunderbolt," undermining the concepts and assumptions around which art history had developed as a discipline. Two seminal sources of early revisionist art history were Linda Nochlin's 1971 essay "Why Are There No Great Women Artists?" which not only took on the masculine construction of genius but also challenged the idea of "greatness" as an art historical category, and T. J. Clark's books on Courbet and the Revolution of 1848 (Clark, 1973a and b, 1974). Clark's studies resuscitated the question of social determination in art— which had been suppressed and invalidated dur-

ing the Cold War—in a way that was both rigorously art historical and theoretically complex.

Nochlin and Clark were pioneers in a movement that eventually transformed the discipline, despite that fact that the majority of practitioners continue to subscribe to the kind of conventional art history represented by H. W. Janson's *History of Art*. Today's College Art Association meetings reflect the dominant influence of a critically aware minority who study art within broad critical frameworks, such as feminism, social history, politics, and economics.

To the extent that there is a "revisionist" outlook, it is grounded in criticizing the idea that a work of art possesses universal or transcendent meaning. Works of art are considered as artifacts or historical records, so that uncovering their meaning demands a study of the social and cultural conditions of their production. To get at that past, however, requires "stripping away all the layers of meaning that have since accumulated around a work like the *Mona Lisa*—how it came to symbolize France's claim to have inherited from Italy the legacy of Western civilization and why it functions today as one of the premier symbols of French culture and the French state."

Because a central aspect of revisionist art history is its critique of Eurocentrism, this critique is a precondition of a multiculturalist approach to the history of art. Wallach stressed

the word "approach" because multiculturalism is not something that "can simply be tacked on to more traditional approaches, as if adding exhibitions of African-American or Chicano art to the National Gallery's exhibition schedule would somehow counterbalance the unabashed Eurocentrism of ventures such as *El Jaleo*." A multiculturalist art history implies a far more ambitious program of "radical democratization: the undermining of established cultural hierarchies, the redistribution of cultural power. . . . It is precisely this culturally transformative potential of multiculturalism that makes it so threatening to its opponents."

Cultural transformation will not come about without social change, maintained Wallach. While one could argue that the critique of Eurocentrism is gaining ground, however, multiculturalism is in constant danger "of being transformed into its opposite," of becoming an excuse for ghettoization and for deepening divisions between cultural groups. For example, while the Smithsonian Institution has begun building museums of African-American and Native-American art, the far more visible and prestigious National Gallery remains a monument to Eurocentrism.

Today multicultural initiatives have the added burden of taking on a well-funded and determined opposition. Right-wing think tanks and journals such as *New Criterion* and *Commentary* identify multiculturalism with the buzzword "political correctness" and cast it as a "barbarian plot" against Western civilization. Despite the thinness of their arguments, Wallach observed, the neoconservatives, who now dominate the NEA and NEH, have greater access to the media than their opponents and have managed to set the terms of the debate. As the United States has become increasingly divided between "dour, self-appointed custodians of traditional concepts of art and culture" and those advocating cultural change, academics and cultural workers find themselves similarly polarized. For academics, suggested Wallach, "the price of choice may be high . . . but the price of not choosing will be even higher."

In the final analysis, Wallach believes that revisionist art history, with its informed and critical assessment of art and its commitment to cultural diversity, enjoys greater credibility than does the neoconservatives' "freeze-dried Parnassus." The basic question—whose version of art history will predominate?—is, ultimately, a deeply political one, forcing us to choose between "the exclusive, mystified culture of the past and the far more open, diverse, and democratic culture of the future."

THE EFFECT OF CULTURAL DIVERSITY ON AESTHETICS

MARCIA MUELDER EATON

Professor of Philosophy
University of Minnesota
Minneapolis, MN

Marcia Eaton explained that many of her observations would be personal ones, drawn from her experience as a member of an analytically inclined philosophy department. She then identified three ways in which cultural diversity has affected aesthetics. The first is positive and significant, but has left the field relatively unchanged. It consists of multiculturalism's broadening of the field of questions and topics addressed by aesthetics. In the last decade, journals of aesthetics have made reference to quilts, rap music, carnivals, masks, pornography—a host of objects and events that were not previously within the purview of aesthetics.

While the examples have changed, Eaton observed, the basic questions have not: "What is art? What is an aesthetic experience? What is the difference between good and bad art? How does one correctly interpret or evaluate art?" While endorsing this expansion in the scope of aesthetic inquiry, Eaton acknowledged that multiculturalism has had little effect on the basic framework of aesthetic inquiry.

In another sense, however, the expansion of possible objects and examples has affected the philosophy of art because, as the set of examples grows, one must reformulate the problem of "what qualifications members of the set must possess." At one time Aristotle's assumption that "all art is imitation" permeated aesthetic theory. However, with the advent of nonrepresentational art, philosophers were forced to reject the Greek paradigm. Throughout most of this century, the operating assumption of mainstream aesthetic philosophy has been that aesthetic experience consists of "disinterested" attention to formal qualities. Not all aestheticians have subscribed to this view, of course, with Marxist and psychoanalytic theorists being notable exceptions. Recent attention to culturally diverse art, however, has widened acceptance of the view that form and content are not separable, or that aesthetic experience can be isolated from other areas of human experience, including politics, religion, morality, or economics. Useful, everyday objects, such as quilts, are now included in museum collections, a development that marks a notable change in aesthetic theory.

Eaton noted that cultural diversity and the demands it places on traditional disciplines have met with considerable resistance. This resistance is the third effect of cultural diversity on aesthetics that she identified. One reason for this resistance is fear—of losing power, of changing standards, of "the other." However, there is

another reason for resistance that is exacerbated, rather than diminished, by one's own cultural interaction. This is the fear of "doing philosophy" in a culture other than one's own.

Cultural diversity has called attention to the fact that everyone inevitably carries his or her own cultural presuppositions and predispositions with them. These presuppositions are a condition of "fluency" in a particular culture, allowing participants to communicate effectively with one another. Eaton noted that it is only deep familiarity with a subculture that enables one to understand the differences in meaning that may be contained in an identical statement: "'Pretty good' is a term of high praise in Minnesota, but not in California," she noted drolly. Given such translation problems within a single culture, the difficulties a Westerner would have in understanding Ilongot art are obvious.

While multicultural art education can give students "access to the significant achievements of our civilization as well as those of other civilizations," as Stephen Dobbs noted in *The DBAE Handbook* (1992), we must remember that art and culture are inseparable: "Art provides access to culture—but culture also provides access to art." How much one must know about a culture before one has any access to its art is a compelling and difficult problem, asserted Eaton.

The difficulty of gaining access to other cultures, and thus to the type of philosophical questions most appropriate to their art, is a key factor hindering the development of cross-cultural aesthetic theory. Nevertheless, Eaton offered some basis for optimism, noting that whether dealing with Malays, Alaskans, rural Minnesotans, Amish quilters, or African-American rappers, one can turn to "native speakers" as "translators" whose fluency can act as a bridge to our own understanding.

Returning to the quilt example, Eaton pointed out that the more we listen to members of a quilt-making culture, the more we realize that not everyone believes that quilts should be hanging in museums. A growing number of feminist critics have argued that the true aesthetic experience of quilts is derived from encountering them in their proper context, "on real beds, keeping real bodies warm." Only through fluency in the concerns and convictions of quilters themselves can the full aesthetic implications of quilts be addressed.

But should a philosopher be "paralyzed" by such a realization? Eaton thinks not, recommending, however, that the difficulties of true multiculturalism be recognized and acknowledged. If we expect "translators" to provide us with access to their culture, we must be prepared to develop comparable fluency in our own culture and

become translators in return: "Giving up Shakespeare or Giotto may be good if it symbolizes that 'ours' is not all there is." But, she warned, we must guard against becoming cultural dilettantes who have no real fluency anywhere and, hence, are unable to do real philosophical work.

Eaton admitted that she did not have the fluency necessary to do aesthetics in a non-Western culture, and that the problems important to her may not be compelling to others. However, she hoped that by broadening examples and questioning assumptions she could make philosophical aesthetics more accessible and "user friendly," even to those who "grew up with rap rather than opera and who make quilts instead of oil paintings."

MAKE IT REAL: NOTES ON PLURALISM EMPIRICAL CRITICISM, AND THE PRESENT MOMENT

ROBERT STORR

Curator

Museum of Modern Art

New York, NY

Robert Storr described himself as a painter, critic, and curator, identities that are in some ways conflicting, in other ways complementary. His experience of living and working in Latin America and Europe, and his current residence in a Brooklyn neighborhood that is 90 percent African American and 60 percent West Indian, has convinced him that the idea of a self-contained Western culture, let alone a single American culture, is a myth. Given this public reality, Storr is sure that, despite the narrowness of the current cultural debate, "the tense pluralism that is the common fact of our existence will inevitably be recognized as *the* positive force in an evolving, rather than static and self-insulating, artistic tradition."

Unfortunately, for those who hope for a genuine opening up in the cultural arena, Storr lamented the recent debate over multiculturalism has "become a bore," losing its hold on the public imagination. The degeneration and dissipation of the discourse, however, has not rendered continued attention to the problems of multiculturalism any less necessary. Quite the contrary, it makes heightened awareness and a "more supple" critical response to exceptional artworks more important. If we are to salvage the prospect of a broadly defined American, or even world, culture, we must find the language to describe "what is missing" from existing culture in ways that both make it desirable and, counter the arguments of those who "fear, ridicule, and condemn diversity." Unless this is accomplished, Storr argued, things will not improve.

Storr presented three preliminary problems in the debate over multiculturalism. First, ours is not an open society, he maintained. Barriers to education and access are genuine, and information circulating within social, ethnic, and economically disparate groups seldom crosses these barriers easily. Despite the fact that some progress has been made in breaking down these barriers in the last forty years, that progress has been reversed by a "backlash at least as powerful as the initial push toward pluralism." Further, the habit of comparing America favorably to more restrictive cultures does not make ours more open. However, it does betray the polemicists who make the point, revealing that the essence of their concern is competition with other cultures and not the struggle to have our own culture live up to its own promise.

Second, and less obviously, the multicultural debate is being carried on for at least the second

time by many of its principal antagonists, who are now showing a sense of frustration and bitterness. Perhaps, he suggested, it is time to abandon the apocalyptic rhetoric and acknowledge that it is highly unlikely that the present struggle will end in either a "golden age" or a final collapse into decadence: "The problem facing us as a country is not epochal dynamism of a positive or negative kind, it is the fact that we are stalled and living below the level of our intelligence, our capacity for change, and the consciousness of our mutual interdependence."

Finally, Storr pointed out that no argument claiming to defend or enlarge cultural values will succeed if it "cheapens the language, obscures the obvious facts . . . and plays to the lowest instincts of group resentment or vanity instead of addressing its audience's highest common level of experience and doubt." However, if all parties to the argument share blame for its degeneration, asserted Storr, they do not share it equally: "Whatever the sins of the cultural zealots on the radical Left, those committed by radical reactionaries have had far more impact on national policy. A witch-hunt is being conducted in the artistic sphere and the national, state, and even private patronage systems are hostage to it."

Turning to the ways in which the critical community has dealt with the question of cultural diversity, Storr explained that there was a "generational split," not only between various critics, but between critics and their audiences. The older generation of critics fought its battles over "liberal anticommunism" and the antagonism between popular and high culture that Clement Greenberg dichotomized as "avant-garde and kitsch." This group's consciousness was formed by the Depression, the New Deal, labor struggles, the Second World War, Stalinism, and the shattering of the Old Left. These critics, many of whom were Jewish, well understand the problems of cultural exclusion and assimilation. Unfortunately, some have forgotten the historical specificity of their own experience and "impatiently ask why the next group does not do it 'their' way, as if such were possible or desirable."

The younger generation of critics, of which Storr is a member, fought different battles—over civil rights and "illiberal anticommunism," in other words, the abuse of American power abroad and against dissidents at home. They also engaged in the debate over popular and high culture with far more insight and discrimination than the first generation gave them credit for. As a group they were better educated and more economically privileged than their elders. A few of them joined the New Left; many more of them joined marches or leafletted for causes.

As different as these two groups' experiences are from one another, they are both differ-

ent from the experience of the generation that constitutes, increasingly, their audience. Those who have come of age in the seventies and eighties have experienced domestic peace, the cynical "benign neglect" of racial and social issues, and comparative economic scarcity. The Left, old or new, was an anachronism and the "end of ideology" was declared. The era of the sixties, including the Black nationalism, feminism, and gay rights that the decade engendered, was "not part of their reality, and what they had heard about it was largely bad. Skepticism and fear of the future have made this generation receptive to any voice that says 'tend to your own business.' "

Storr is convinced that this "mainstream" audience is not so much opposed to multiculturalism as it is resistant to "externally imposed obligations." Racial, sexual, or class-defined guilt alone does not move it, and this is only appropriate: "One should not read books to expiate the guilt of not having read them, or look at pictures because one should look at them." Such negative arguments are more likely to close than to open minds.

The "duty theory" of multicultural education has actually played into the hands of the reactionary Right, proposed Storr, by enabling them to make generalizations about the diverse interests and diverging approaches it actually represents. Typical of these generalizations are that: people who are "politically correct" (PC) all agree and demand agreement from others; people who are PC are elitist; people who are PC are the beneficiaries of unearned privilege and private means and ask others to make sacrifices only they can afford; people who are PC are opposed to tradition because they are ignorant of anything but ideas about social responsibility and disdain the aesthetic pleasures of the past. Once the PC label has been invoked nothing one says will matter to a skeptical public: the use of "PC is bigotry by abbreviation."

The image conjured by the Right, of a monolithic, undifferentiated horde of "others" making unfair demands on an innocent public draws on the time-honored tropes of ideological warfare: It is the Red Menace, the Yellow Peril, Black Rage, and the Spanish Inquisition rolled into one. In such a worldview, a complex historical phenomenon such as feminism is recast as an aberrational episode in the "war between the sexes," and "women's hysteria" is countered by the ostensibly "logical" discourse of non- or antifeminists. The epithetical use of labels preempts analysis with stunning efficiency, so that a curator who exhibits the work of a number of women is tagged a "feminist" and denied further consideration by the Right, which considers all feminists the same.

African-American artists are treated similarly when Whites tap into deeper and more sub-

tle forms of prejudice. The idea, at once discriminatory and hopeful, that Black artists are there to tell the public what "Blacks think," is implicitly racist: "Craving absolution for biases . . . or hoping to prove their sympathy . . . Whites will inevitably ask, 'What does it feel like—really—to be Black?'"

As an example of this mentality, Storr cited a recent show he curated at the Museum of Modern Art called "Dislocations." Two of the seven artists featured were African American, David Hammons and Adrian Piper. Hammons has worked primarily in public spaces and not in the sterile "white cube" of the museum. Bringing the "outdoors in," Hammons recreated the equestrian statue of Teddy Roosevelt in front of the Museum of Natural History, which is attended by representations of two "noble savages," one Indian and one African. He "attacked" the statue with plastic airplanes, movie prop machine guns, and fake TNT.

Piper's work took a radically different approach and was constructed within an all-white room that was itself a minimalist sculpture. Lined with mirrors, the room contained a video box with the image of an African-American man who repeated the phrases "I am not horny. I am not shiftless," and so on. Critical response to the show was mixed, but with distressing frequency the works by Piper and Hammons were described as

being equivalent in their content and "just" about racism: "It occurred to few that the obvious *subject matter* did not exhaust the by no means obvious *content*—a distinction that normally sophisticated critics would have made if the subject matter had been something else." The dramatic formal differences between the two pieces, which implied major differences in the viewpoints of the artists, were totally ignored.

Hammons is an artist who wants to "get people out of museums and into the world. He wants to make beauty out of trash" and to get viewers to confront directly their ignorance and preconceptions. However, the anger in this piece is mediated by "humor and finesse," and he meets the viewer more than halfway across the social gap separating artist and audience. Piper, in contrast, is a Kantian philosopher who embraces the universal values embodied in pure abstraction. But, however deep her involvement in pure art, she wants us to know that "the man in the box will not go away, and his recitation and denial of racial slurs is not just a guilt trip addressed to Whites, but a necessary, daily litany painfully repeated to himself as well as to all within the range of his voice. Anyone looking to discover "what Blacks think" would discover from this show that Black artists think many different things, and that racism consists in "treating *the many* as if they are *one and the same.*"

There is much work by artists whose cultural identity informs their work, but whose identity is not necessarily declared openly on the surface of that work. There are Latin American artists who create hard-edged geometric paintings and African Americans who are minimalists. To appreciate such work one must think about how artists use common cultural property and alter it in light of their intentions and background, a process that poses a special challenge for contemporary critics. "Are North Americans aware that much South American art consists of ruled squares and circles rather than pre-Columbian, colonial, revolutionary, or surrealist iconography?" Storr wondered.

Artists do not make art about pluralism, insisted Storr, and pluralist critics do not particularly enjoy belaboring the issue either. Both would much rather be free to study what interests them and what they believe will interest others. For that reason, and others previously mentioned, Storr announced that he intended to "stop talking about multiculturalism altogether." He did not intend to stop showing and writing about artists whose work raises this issue and gives it form, however, "for only the breadth and richness of pluralist culture itself can put an end to the demoralizing efforts some are making to diminish our common heritage and our future."

HOW HAVE ISSUES OF CULTURAL DIVERSITY AFFECTED PRACTICES IN ART MAKING?

ALFRED J. QUIROZ
Assistant Professor
Department of Fine Art
University of Arizona
Tucson, AZ

"Cultural diversity," "multiculturalism," and "people of color" are terms that have been sweeping the country since the civil rights movement in the 1960s, observed Alfred Quiroz. The demand of African Americans, Native Americans, and Hispanics for voice in society coincided with a new assertiveness on the part of minority artists, who still worked on the margins as the mainstream embraced Abstract Expressionism and then Pop in the postwar era.

Quiroz noted that when he was growing up in the fifties and sixties the arts world contained no "crossover" role models that young, culturally diverse artists could follow. By the early seventies, a Third World art movement had emerged as ethnic artists searched for their own niche in the American art community. Key to their artistic evolution was higher education. Quiroz estimated that the majority of ethnically diverse artists today have at least one, and sometimes two, graduate degrees in the fine arts. Interestingly, an Associated Press article (July 6, 1992), reporting that 86.6 percent of teachers are White, suggests that the lack of role models for

non-Whites continues today and will remain so for years to come.

While many artists of Quiroz's generation were raised on the myth of the "melting pot," they soon found that, as artists, they were expected to "depict the accepted iconography of their ethnicity." He recalled that in the seventies he was rejected by a government-funded Latin organization for a mural project in San Francisco on the grounds that his work "was not Chicano enough." Examples of this type of aesthetic discrimination still abound, as evidenced by the recent show, "Chicano Art: Resistance and Affirmation," where only Chicano artists working in specific ethnic genres were exhibited.

Quiroz believes that prefacing artworks with terms like "Afro-American," or "Chicano" was simply another method of denigrating the work by granting it quasi-folk status. Significantly, such qualifiers are not used for Irish-American or Jewish-American artists. He believes that the "ultimate goal of any educated artist living and working in the U.S. is that he or she . . . be recognized as producing American art. . . ." Unfortunately, in the guise of "political correctness," writers, educators, and dealers continue to tag art by non-Whites as a way of giving it "exotic appeal." To support his assertion, Quiroz recalled that a New York dealer's interest in his work waned when he discovered the artist was from

Arizona: "Central Americans are really in now—I can't push your work if you're from Arizona."

Citing the crossover artists Luis Jiménez and Robert Colescott as inspirations, Quiroz explained that in his own work he uses a tableau format, combined with the style of cartoons and comic strips, to address the aggressive military history of the United States. In doing so, he draws on the cartoons and comics of his childhood and the muralist's technique of teaching history through images. The aim of his art is to "disturb you and make you fully aware that war is racial genocide." Because of its confrontational nature, Quiroz recalled, he was called a racist by one "Anglo" professor. However, he believes strongly that art should be critical and confrontational so that it can better compete for attention with television and other mass media.

As an assistant professor at the University of Arizona, Quiroz is often asked to serve on a variety of committees as "minority filler to round out quotas." His sense of being a token would be less pronounced, he surmised, if he were not the only Mexican American on the art department faculty. Despite this reservation, however, Quiroz was enthusiastic about the strength and diversity revealed in the work of ethnic artists today. Artists such as Wilfredo Castaño, Judith Baca, Horace Washington, and Jaune Quick-to-See-Smith have used elements drawn from traditional art, modern masters, and contemporary developments to create new expressions. As Guillermo Gomez-Peña has noted in *Art in America:*

> The U.S. is no longer the heir of Western European culture—instead it is a bizarre laboratory in which all the races and all continents are experimenting with identity, trying to find a new model of conviviality. In this process, very exciting kinds of hybrid art forms are being created. Unfortunately, violence, misunderstanding, and fear are also created (1991, p. 126).

According to Gomez-Peña, as an unprecedented spotlight shines on Third World artists, are they being regarded as "the new intellectuals or the new primitives?" Nevertheless, despite the recent cutbacks in federal arts money, and the dismantling of the cultural ground gained during the civil rights movement, Gomez-Peña is confident that, out of grievances and turmoil, good art is being produced.

DBAE and Other Disciplines:
Three Perspectives

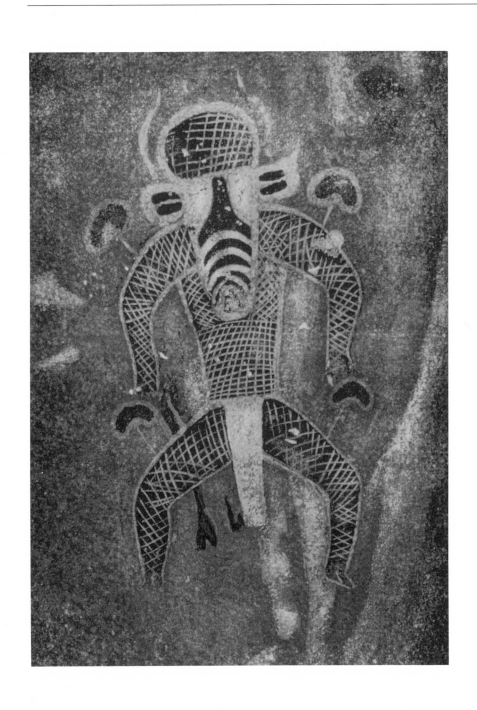

Shaman
Tassili N'Ajjer, Algeria
6,000 years before present

INTRODUCTION

MARTIN ROSENBERG
Associate Professor
Department of Art History
University of Nebraska
Omaha, NE

As an art historian working with the Nebraska Regional Institute, and a member of the Getty Center advisory committee, Martin Rosenberg was excited by the level of commitment to the issue of cultural diversity shown by the participants. He thanked Michael Kendall and the Getty Center staff for their efforts in organizing this conference. The Fourth Plenary, he explained, was devoted to how developments in other disciplines could enhance DBAE theory and practice and consisted of three presentations.

The first presenter, June King McFee, was unable to attend. Her paper was read by her colleague, Rogena Degge. Dr. McFee is Professor Emeritus at the University of Oregon and was a pioneer in the area of cultural diversity and art education. Her studies of art and culture have covered a wide variety of topics and have contributed greatly to the field. She also developed doctoral programs in art education at Stanford, Arizona State, and the University of Oregon. Rogena Degge is Professor of Art Education at the University of Oregon. The textbook they wrote together, *Art, Culture, and Environment,* has just been reissued.

Marianna Torgovnick is Professor of English at Duke University. She teaches courses in the novel, modernism, and cultural studies. A prolific author, Dr. Torgovnick's most recent book is the critically acclaimed *Gone Primitive,* an exploration of the West's obsession with the idea of the primitive.

The third presentation is a joint effort by Fred Wilson and Lisa Corrin. Fred Wilson is an installation artist who has also served as a museum educator and curator. He creates museum environments that call attention to the political and philosophical agendas underlying traditional museum practices. Lisa Corrin is Assistant Director and Curator at the Museum for Contemporary Arts in Baltimore. Much of her work has involved initiating unusual, cross-disciplinary collaborations between museums and educational, cultural, and social service institutions. Their presentation focuses on Fred Wilson's installation at the Maryland Historical Society, "Mining the Museum."

DBAE AND CULTURAL DIVERSITY: SOME PERSPECTIVES FROM THE SOCIAL SCIENCES

JUNE KING MCFEE
Professor Emeritus
University of Oregon
Eugene, OR

June McFee addressed the impact of multiculturalism on the content of art-teaching in schools. She began by noting that DBAE uses the arts disciplines of studio practice, criticism, aesthetics, and art history to shape the content of arts education. However, she proposed that the cognitive, perceptual, and learning aspects of the social and behavioral sciences should also be included in DBAE to better address differences in student aptitudes for learning about, responding to, and creating art.

Thirty years ago, McFee recalled, some educators were calling for a greater recognition of cultural diversity in art education. Unfortunately, the call went largely unheeded. Now, when cultural diversity is far greater, the need for pedagogical change has reached crisis proportions. Variations in student backgrounds greatly compound the problems of teaching and learning, as do the divisive effects of poverty and changing mores and life-styles.

The cultural gulf between the assumptions of Western fine arts and the majority of the school population is greater than ever. This implies that students need not only to comprehend and critique art within their own culture, but also to understand the function of art in other people's cultures if we are to increase cross-cultural awareness and respect. Because the visual arts are a rich source of information about individuals and groups—their identities, cherished meanings, and life-styles—they are uniquely suited to such a task. However, multicultural education must do more than expose students to the art of different cultures—it must also consider the cultural diversity of students themselves, their different learning styles, value systems, and perceptual modes.

Art, as a form of cultural communication, is one of the basic language skills students need to participate in a multicultural democracy, noted McFee. To develop an effective art curriculum, therefore, teachers must be knowledgeable about how art functions in various cultures, including their own and their students'. Art is a "window to culture" that helps students to see themselves as part of a culturally diverse society.

McFee then briefly reviewed the history of the sociocultural foundations of art education. She noted that in the fifties and sixties some efforts were made to incorporate the art of Native Americans, African Americans, Eskimos, Hispanics, and Asians into the art curriculum as a way of bolstering appreciation for the contributions these cultures made to American art. Dur-

ing the 1960s, there was also a heightened awareness of how cultural differences among economically deprived students affected learning.

In the mid-1960s, the conflict between "mainstream" culture and the counterculture increased, spreading to the working, middle, professional, and upper classes, and particularly to artists and art educators. Simultaneously, a resurgence in ethnic group consciousness took place. In their concern that Black art and culture was being eclipsed in mainstream educational practice, Black educators petitioned the NAEA board of directors to appoint a committee devoted to the problems of minority teachers and students. This group, the Committee on Minority Concerns, has grown over the years and has published several works including *Art, Culture, and Ethnicity,* a volume of case studies and reviews addressing minority issues.

Additionally, in 1974, a women's caucus was formed that has since produced an extensive body of research and literature. McFee recommended that the work of both of these groups be analyzed for their insights into the sociocultural foundations of art education.

During the seventies and eighties, several international conferences in the field were devoted to cultural diversity in the arts and its implications for teaching. McFee's own writings included *Preparation for Art* (1970), which focused on the sociocultural factors in learning about and producing art, and *Art, Culture, and Environment* (1977), with Rogena Degge, which tied cultural diversity to individual perceptual, cognitive, and developmental differences. Her chapter, "Cultural Dimensions in the Teaching of Art," in the anthology *The Foundations of Aesthetics, Art, and Art Education* (1988), reviewed literature from anthropology, cross-cultural psychology, and educational anthropology that was related to multicultural art education. Many of McFee's former students, including Degge, Efland, Silverman, Boyer, Chalmers, Lovano-Kerr, Hamblen, Congdon, Jones, Ettinger, Johnson, Wasson, Guilfoil, and Lanier have made contributions to the literature on interdisciplinary and multicultural art education. Their work, together with that of many others, could be brought together with relevant work in the social sciences to provide an interdisciplinary sociocultural foundation for DBAE.

McFee noted that the word *culture,* as used in the social sciences, differs from the more common use of the word, which refers to a "state of cultivated refinement in art and manners." In its broadest sense, culture refers to the belief systems, patterns of behavior, and artifacts that develop within any cultural group. Cross-cultural psychologists have studied the variations in cognitive style that exist within and between cul-

tures—"the ways that people attend to, sort, and organize concepts, things, qualities, and quantities." An understanding of these differences is particularly important in multicultural art education because art can be validly judged only if students use criteria for judgment based in some way in the symbolic systems employed by the creators. McFee observed that, as our very neighborhoods become microcosms of diversity, "we no longer have to go somewhere else to find carriers of other cultures."

The rapid rate of change in the world, accelerated by modernization, the market, and communications technology, means that once-static cultures are under intense pressure to change. Sometimes these forces produce strong reactions that bring about intense efforts to conserve traditional values.

Today, many children are growing up in multicultural families. They may have parents from different backgrounds who are themselves living in a third cultural environment. It is no wonder that these children have a difficult time adjusting to a fourth culture—that of the American public school. When discussing multicultural art education, teachers need to consider what degree of cultural change students are experiencing in school, as well as their background culture.

Anthropologists have provided insights into culture that are useful for art educators. Other cultures often do not have the kind of formal aesthetics practiced in the West, but they do have highly developed ideas about value and quality in art. Ideas about art, its purposes, its methods, and its forms and definition are so embedded in a culture that they are taken for granted by its members. If we allow our Western notions of aesthetics to condition our perceptions of other arts, however, we will be unable to understand the messages such art bears about the culture that produced it.

In any culture artists can either reinforce traditional values, or challenge those values through critical artistic practices. Artists may be devising new ways of thinking and organizing messages by employing materials or ideas that are not culturally acceptable to the mainstream. McFee suggested that teachers should be careful in their selection of art from other cultures and be aware of whether their choices are peripheral and critical or central and reinforcing to a given culture. She also recommended that the full range of the visual arts operating within a culture be explored, including crafts, advertising, graphics, costume, architecture, and popular imagery.

A multicultural educational environment occurs whenever a teacher from one cultural background attempts to teach children from another culture—an increasingly frequent situation. However, multicultural education only takes

place if the teacher is sensitive to the function of art in cultures represented by the students. The range of diversity now present in some classrooms demands that we develop strategies for teaching art in multicultural settings, even though a single teacher cannot understand each one of the cultures represented.

Although this is a difficult challenge, McFee suggested a few promising strategies. First, emphasis can be put on the study of art as a form of cultural communication. This requires relating art to its cultural context and asking students what messages they are receiving from it, how it is organized, how it is made, and how it is valued by its audience. Second, curriculum developers can use culture-based social studies in elementary and middle schools to relate art instruction to the people and cultures being studied. Students thus learn how the values and attitudes of those people affect the way their art is created. Comparisons may then be made to the art and culture among various groups.

To do this, teachers will need the skills to discover students' impressions and tastes, to analyze why they like or dislike certain works, and to understand how their own cultural background influences the perceptual process. They will need some experience in analyzing their own cultural assumptions and preferences, and a background in world cultures and in studio work. McFee recommended that education courses be integrated into a theoretical and practical framework designed to help future teachers use culturally diverse curricula and material, as well as to develop materials to fit their particular cultural setting and circumstances. Finally, teachers must increase their own cultural sensitivity if they are to help heal the "explosive conflicts that arise from intercultural misunderstanding."

LEARNING FROM LITERATURE

MARIANNA TORGOVNICK
Professor of English
Duke University
Durham, NC

Consciousness of cultural diversity in English departments, observed Marianna Torgovnick, grew out of a boredom and discontent with close textual readings, which had been the foundational methodology of the discipline throughout the post-World War II educational boom. Close reading, which resembles the analytical techniques of iconography and formal analysis in art history, traces how style and thematic patterns function within an individual work. Such language-based approaches, which include New Criticism, the French explication de texte, and more recently deconstruction, carved out a distinctive territory for the professor of literature.

Language-based approaches, whether traditional or innovative, tend to accept "the canon," the body of work that is agreed to represent the literary heritage of a nation. In the United States adherence to the canon had the virtue of providing a unified literary identity to a nation peopled by representatives of many different cultures. Its disadvantage was that it perpetuated the myth that the nation's common heritage was English and Protestant.

Although close reading side-stepped the issues of historical context and social impact, it served the discipline well for many years, providing clear and transmittable skills for teachers and critics. Through its emphasis on interpretation, close reading gave the scholar "some of the power and aura of the writer him- or herself."

Before close reading could give way to "cultural studies," the field that allows critics to bring social issues to bear on literature, there needed to be a respectable body of literary criticism that moved outside the traditional boundaries of English and into other disciplines and social phenomena. There also needed to be a professoriat open to the possibilities of such an approach. In the late sixties, a sense of political engagement, galvanized by protests against the Vietnam War, the rise of feminism, the civil rights movement, and other movements, infused English departments. The professoriat expanded to include members of different racial, ethnic, class, and gender backgrounds. Aware of their difference from the professors who had taught them, students began to question why their concerns and experiences should be excluded from the classroom and began to "integrate the outside world . . . into their work."

Edward Said led the way in 1975 with the publication of *Orientalism,* a passionate and personal book that analyzed Western images of "the

Arab." This work and others like it inspired a generation of scholars to consider issues long neglected in literary criticism: race, ethnicity, canon formation, and the way the study of literature served liberatory or oppressive goals: It was now the responsibility of the literary critic to "also be a critic of the excesses and flaws of his or her own culture."

Torgovnick noted that after the Israeli victory in the Seven Days War in 1967, Said, who had previously identified himself as Lebanese, announced that he was actually a Palestinian. He began to write about Palestine and became a member of the Palestinian National Council, the government in exile. In *Orientalism,* Said performs traditional critical activities, such as close reading and textual analysis. But as a later book, *After the Last Sky,* makes clear, Said does so in the context of his family and the loss of his father's house, his own alienation and pain, and the way the Western perception of Arabs has affected his life. Said became the model of the committed critic, illustrating the degree to which commitment and passion is "necessary to making cultural diversity work."

After Said, newcomers to the field began to bring the "fundamental facts of their existence" to bear on their professional practice. Female critics addressed the lack of women in the canon and African-Americans did the same for African American and Caribbean writers, expanding the canon in the process of challenging it. This work of canon expansion made cultural diversity important in education: "It involved the hard work of textual recovery and discovery, editing, and historical reconstruction . . . and the teaching of brilliant but unfamiliar works."

Today, the texts that once represented "cultural diversity" are part of the regular curriculum in English and American literature departments. Canon formation is an ongoing process, noted Torgovnick. But canon revision should not just be about adding cultures. It should also be about uncovering new things in traditional Western culture. Despite the misconception that feminist, African-American, and other approaches have displaced Chaucer, Shakespeare, and Milton, this is far from the truth. More accurately, literature departments have been able to expand and diversify their offerings during an exciting period of growth.

Torgovnick's own recent work, *Gone Primitive,* is about Western culture's fascination with what have been called "primitive" people— Africans, Amazonian Indians, Native Americans, and others. It discusses the work of Malinowski and Margaret Mead, Lukacs, Freud, and Lévi-Strauss, as well as a wide range of texts, such as Tarzan novels, Joseph Conrad, and television travelogues. She wrote the book in a deliberately

experimental and accessible style and made it as personal and passionate a book as possible, something she would not have had the courage to do before the aforesaid changes in the culture of English departments.

The changes that took place between 1975, when Torgovnick finished her dissertation, and 1990, when she published *Gone Primitive*, could be summarized under the broad heading of "theory." Just as literary scholars were raising questions about the nature of interpretation that had once been the province of philosophers, the work of literary theorists like Bakhtin, Foucault, Barthes, and Derrida was being cited by art historians, anthropologists, and psychologists. For English professors, intellectual life was truly interdisciplinary in a way few had anticipated.

Interdisciplinarity is frequently misunderstood, observed Torgovnick. In most cases literary scholars are not interested in examining art, anthropology, history, or psychology from within the assumptions and methods of those fields. Rather, they seek to bring the insights and discoveries of their own field to bear in an attempt to generate fresh perspectives. In 1992, interdisciplinarity has become a feature of so many people's work that a new term has been borrowed from England to describe it: cultural studies. As originally constituted at the University of Birmingham, cultural studies was grounded in the analysis of class structure. Today it is an umbrella term almost synonymous with "cultural criticism."

Literary scholars no longer find themselves accurately described by the term "literary," inasmuch as they often address disciplines and media other than literature. Additionally, they are reaching audiences outside their field, broadly influencing other disciplines, boosting enrollments in English, and taking a leadership role in the development of new areas of study. There is a negative aspect to these developments, however, suggested Torgovnick. Graduate students faced with so many new possibilities may not be getting the best possible training: "When I was in graduate school, a professor used to say 'You've got to read Aristotle.' Now I hear myself saying 'You've got to read something written before 1970.'"

Torgovnick, like other English professors, still teaches the canonical literary texts: James, Woolf, Shakespeare's sonnets, Donne, Milton, Wordsworth, and Keats. Nevertheless, she has noticed an unpleasant backlash against cultural studies developing within and outside the academic community. Allan Bloom, Dinesh D'Souza, and Lynne Cheney among others have made it fashionable to attack professors for high salaries, for neglecting students, and for undermining the fabric of U.S. culture, generating a level of media

attention "beyond anything that English professors ever expected."

The introduction of cultural diversity into art education at any level will not hurt the future of art education, which Torgovnick thought resembled English before the late 1970s. Art education needs to move beyond source study, iconography, and formal analysis and needs to become more aware of art traditions outside Europe and the United States. Awareness of cultural diversity, with the social and cultural viewpoints that implies, will help art education grow. However, Torgovnick suggested, the art field might want to learn from the experience of English and plan strategies and build networks against the inevitable backlash.

In English departments, those who favor cultural diversity did not pay attention to what traditionalists were feeling and thinking and established too much of an "us/them" mentality around cultural diversity: "We are still wrestling with the results." Nor has there been in English much contact between university departments and primary or secondary educators. Torgovnick considered that a mistake, both intellectually and strategically.

"On the continuum between optimist and pessimist, I find myself hugging different poles on different days," revealed Torgovnick. However, she was convinced that the issues were important and worth fighting for and that, "if we teach and write what we care about and believe, then we cannot really fail."

LISA CORRIN

Project Guest Curator

The Museum for Contemporary Arts

Baltimore, MD

Lisa Corrin described Fred Wilson's install tion "Mining the Museum" as a project that "lay bare the ideological systems underlying museum practices and galvanized the development of an education strategy that was designed for use by visitors and staff." But before discussing Wilson's project in detail, Corrin briefly described her institution, the Museum for Contemporary Arts.

The Contemporary is unique among museums in that it operates in temporary spaces: abandoned buildings, an old garage, a car dealership, or a dance hall. These spaces are transformed into exhibition areas for contemporary art. Because the exhibitions take place in nontraditional settings in a community, they inspire audiences to "let go of apprehensions they may have about entering a museum." It is an implicit part of the Contemporary's mission, Corrin explained, to question and redefine the idea of the museum.

The Contemporary was founded in response to the needs of contemporary artists, who have been challenging the idea that a museum is the only suitable site for the presentation of artworks for the last three decades. Calling attention to the ideology of the museum environment, curatorial practices, and the museum's link to the market and the corporate world, artists argued that the interpretation and reception of art was inherently connected to the "invisible social and ideological systems that underpin museum practice." At the same time, art historical revisionists were undermining the distinctions taken for granted by museum professionals: art/artifact, high/low, style/period, artist/curator, self/other.

However, as Alan Wallach has pointed out in a recent article in *The Chronicle of Higher Education,* there is still an enormous disparity between the new art history and the museum community's programming for the general public. Corrin is convinced that if museums are to remain relevant institutions, they must "take the pulse of their communities" and develop programs that encourage audience participation. Visitors to the Contemporary are regularly asked to question not only what is on exhibit, but why it has been chosen by a curator and how it is displayed. The museum, which provides no answers to these questions, hopes that these lead to even more questions and to the raising of social and political issues suggested by the material. In this way, the museum interrogates the social forces and value systems that shape cultural production and

explores the connections between contemporary art and contemporary life.

Wilson's "Mining the Museum" grew out of the desire of the director of the Maryland Historical Society to bring his traditional institution "up-to-date" in regard to the current concerns and interests of a diverse community. The Contemporary proposed that these two very different museums join forces and invite Wilson, an installation artist known for his "rib-jabbing critiques of museum practices," to develop an exhibition.

Wilson's work has drawn attention to the ways in which curatorial practice affects our understanding of museum collections. His installations, which previously used reproductions of ethnographical objects, call attention to the fact that history is itself an interpretation that is always carried on in the context of contemporary events.

"Mining the Museum" employs the standard display techniques used in museums: labels, lighting, the juxtaposition of objects. Wilson subverts the traditional use of these techniques by having them undercut our "reading" of historical truth. The focus of the exhibition was the African-American and Native American experience in Maryland. One of the first objects encountered was a silver and gold "Truth Trophy" that cast a shadow on the empty acrylic museum stands surrounding it. The display is flanked by two sets of three pedestals. The first set bears three marble

busts of famous White Marylanders, the other three pedestals, of black marble, are empty but bear brass plaques reading "Harriet Tubman," "Benjamin Banneker," and "Frederick Douglass." The questions raised by the juxtaposition—were no busts made of these people? Or were they not considered important enough to include in the collection?—point out the contingency of historical "truth" and who makes it, who learns it, and who passes it on.

Other juxtapositions, such as slave shackles exhibited beside fine silver as "examples of metalwork," and Victorian chairs grouped around a whipping post, make a powerful point. As one critic noted "The artifacts he's dealing with are ours. This is our history he is reexamining and the blind spots he's calling attention to are emblematic of our community's overall collective vision with regard to people of color" (Dumenco, 1992). Corrin reported that Wilson intended "Mining the Museum" to be emblematic of the museum experience, "not all intellectual, but emotional, visceral as well."

Public programming for "Mining the Museum" involves the inclusion of nine area artists who supplemented the regular docents in providing tours and presentations. There was also a panel discussion and a continuing studies class at Johns Hopkins University that focused on the challenge of "exhibiting cultures." Curators

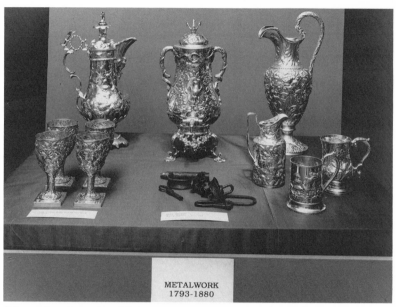

"Examples of metalwork" from *"Mining the Museum,"* Maryland Historical Society, Baltimore.

from other major institutions, such as the Walters Art Gallery and the Baltimore Museum of Art, joined in the critical enterprise. Additionally, the Contemporary has engaged an "outreach specialist," who is working with docents and art educators to create materials and programs for school children in the fall. The program uses rap music, videos, and historical material to help sensitize children to the museum environment. Printed materials are also provided for visitors. These include question sheets and a brief didactic piece approved by the artists, which is available only at the conclusion of the installation in order to preserve the element of surprise.

Corrin maintained that culturally diverse programming starts with self-education and "Mining the Museum" began with a year-long self-study process in which the staffs of the participating museums, including curators, maintenance workers, security guards, and art handlers, examined their individual roles within the institutions. This process, which the staff members are still undergoing, examined common definitions of concepts, such as "museum," "audience," "curator," and "artist," and developed a "think sheet" of topics devised to measure changes in the way individuals saw themselves, the artist, and the institutions. While staff and

volunteers kept an ongoing record of their responses, visitors were encouraged to comment on the exhibition and speak freely about their reactions and expectations. At the conclusion of "Mining the Museum," Corrin explained, these responses will be utilized to develop long- and short-term goals for the museum's policies, practices, and programming.

Almost every evaluation of the exhibition has remarked on its emotional impact and how it prompts individuals to see both the collection and the history of African Americans in a new light. Even the staff members have made repeated visits to the installation, noting that their "insights continue to expand and evolve." The staff, in particular, had to confront their assumptions not only about history, but about their role in the museum itself: "Gradually, the administrators, curators, educators, art handlers, registrars, support staff, and docents began to realize that the way their jobs had been defined previously did not always apply to the role they had assumed in 'Mining the Museum.'" Typically, they were asked to relinquish power to others for the sake of moving forward as an institution. Corrin concluded that "Mining the Museum" offered a unique opportunity for reflection on the role the museum could play in a rapidly changing world.

FRED WILSON
Installation Artist

Fred Wilson began his presentation by thanking the Getty Center for inviting him to their Issues Seminar. Too often, he observed, artists are left out of discussions of art education.

Early in his career, Wilson supported his art by working in the education departments of museums, such as the Metropolitan Museum and the Museum of Natural History in New York. When he had the chance to run his own gallery in a former public school in the South Bronx, he decided to transform some of his observations and insights about museum theory and practice into conceptual art.

One of his first shows, entitled "The Struggle Between Culture, Content and Context," involved inviting thirty artists to exhibit their work in three environments designed by Wilson: the traditional "white cube" favored by exhibitors of modern and contemporary art, an "ethnographic museum" space with glass cabinets and fluorescent lighting; and a "Victorian salon" similar to the type seen at the Frick Museum.

Wilson noticed that contemporary art objects were transformed when placed in any one of these spaces. When exhibited as ethnographic specimens, roped off, organized by function or size, and identified by labels such as "ceramic object, late 20th century," expressive objects lost their individuality and their link with their creator. They became exotic and mysterious. When exhibited in the Victorian salon space with harpsichord music playing in the background, the same objects gained dignity and authority as objects associated with grandeur and wealth. Wilson thought it particularly interesting that the "white cube" functioned as the "great equalizer," conferring on the objects a cold, scientific, rational character they might not have had otherwise.

Wilson began to experiment with this complex relationship between object and context in his own work. In one work, entitled *The Colonial Collection,* he wrapped African masks, bought on the street in New York, in French and British flags and labeled them as spoils of war. Asserting that "the aesthetic anesthetizes the historic," Wilson explained that he intended to enhance the historic reality of such objects by reminding viewers that they were forcibly acquired during punitive expeditions. To evade this fact, he insisted, is to perpetuate the imperial notion of the world.

In a related work, Wilson used labels to communicate a similar idea. Taking a vitrine filled with insect specimens, he labeled the insects with names of countries subject to colonial rule, making the point that these countries were "collected like bugs."

When he carved the names of opportunistic diseases related to AIDS in a similar group of African masks, Wilson was surprised to be assailed by a collector who criticized him for despoiling the spirit of these ostensibly sacred objects. He reassured her that the masks were produced for the market and had never been used for religious purposes, but was struck by the fact that she was more concerned about the misuse of the objects than she was about the diseases that were ravaging their creators.

In the installation at the Maryland Historical society, "Mining the Museum," Wilson again used the juxtaposition of objects to "bring the historic to the aesthetic." Although African Americans constitute 80 percent of the population of Baltimore, their history seemed virtually unrepresented in the collections of the Maryland Historical Society. However, Wilson usually begins his encounters with exhibiting establishments with the question "Where am I in this institution?" This question led to the recovery of the history of African Americans in the Maryland Historical Society in some surprising ways.

Wilson began to notice that in many paintings and photographs, African-Americans were visible, if not central, in the composition. In one painting, two boys, one White, one Black, are shown in a hunting scene. The African American boy, who is facing his White master, was provided with a voice through a audio recording, and asks "Am I your brother? Am I your friend?" A close look at this figure reveals that he wears a metal collar. To call subtle attention this fact, Wilson has since placed a dog collar in the space where this painting is usually exhibited to mark its absence. In another painting of a outdoor fete, entitled *Country Living,* Wilson called attention to the presence of the single African American participant, a servant, by renaming the work *Frederick Serving Fruit.*

Wilson concluded by noting that one does not necessarily need "culturally diverse" objects to make important points about diversity. One only needs to thoroughly explore what is available. By using the exhibition techniques of the museum, including juxtapositions and labeling, Wilson found that it is possible to recover a diverse, if sorrowful, history that is too often overlooked.

QUESTIONS AND ANSWERS

Q: (From the floor) Could you explain what you meant by "the aesthetic anesthetizes the historic"?

A: (Fred Wilson) I was trying to illuminate how the aesthetic can be used to reach people on a deeper level, as opposed to having people read about it. When I say "the aesthetic anesthetizes the historic," I am talking about museum environments, which presume that the aesthetic can only inform formal values. For me, the strength of the visual world, and how artists create that world, is tremendously important. But what I have a problem with is the limited application that people assume this process can have.

Q: (From the floor) As a teacher, I would like to know how I can use your art in my classroom.

A: (Fred Wilson) I like to make installations that are important to a particular community. The Maryland project was important to the art community in the country at large. But if you are from Maryland, you knew the people's names, and the names of the streets, and it had a special resonance. I like to do things in specific locations, and while I have a particular approach, artists in your community may be able to provide a view of art that is different from that held by educators, critics, or curators. That is a more direct way to access the kind of energy I am trying to communicate. I would recommend looking for local artists who will know how to "push buttons" in your community.

Lisa Corrin had the fabulous idea of using artists as docents in the exhibition. There were also the regular docents. At first, they were totally freaked out, but as soon as the children started to tell them what the work was about, they started coming to me. One woman, who really had a problem with my work, admitted eventually that she was glad I had come to the museum. Later, Lisa asked artists to come and give tours, not only of my exhibit, but on art in general. These were very unusual tours, with some artists speaking personally about their relationship to the art, and their reactions, as White artists, to its content. Another artist had visitors peel an onion to demonstrate the "layers of history." Your best bet is to go with artists from your community.

A: (Lisa Corrin) There were pre- and postexhibit handouts and other materials available to visitors. Many of the docents are now going through sensitivity training so that they can discuss the exhibition with the audience from multiple perspectives. Also, a package is being put together by Gloria Franklin that uses a rap song to discuss the importance of understanding history. The kids relate to that message and better understand Fred's work.

A: (Marianna Torgovnick) I want to add that I particularly liked the list of questions that

respected the intelligence of the children. After writing *Gone Primitive,* I got a lot of invitations to go to county historical societies. To cover the fees, I was often asked to talk to school groups. I would usually draw upon the visual material in the book and ask the students to do some writing on narrative questions. I found that kids were already tuned into this stuff; they always wanted to know what their relationship to the material was and who made it.

A: (Lisa Corrin) A professor from Morgan State University used those questions on a final exam in a seminar on "Children and Family" and gave the students a chance to either address the questions themselves, or to talk about how Fred dealt with them. There will be a full-length publication, from The New Press, documenting the show "Mining the Museum." The New Press also publishes other books that relate to the exhibition, including Studs Turkel's new book *Race in America* and the catalog of Joseph Kossuth's exhibition on censorship at the Brooklyn Museum.

Q: (From the floor) I was wondering what Marianna Torgovnick, as an outsider, felt she had gotten from this seminar.

A: (Marianna Torgovnick) Being such a museum hound, I don't really feel like an outsider. What I am taking back from the larger gathering is some of the energy I feel here. When I told my colleagues about what I would be talking about here, some said, "That's a boring topic, it's last year's topic." It was good to be in a group that included people from different segments of the educational spectrum to recreate the controversy, which I don't think has finished at all.

Q: (From the floor) You have spoken about the backlash that has occurred. Could you speak about strategies for dealing with that in academic communities?

A: (Marianna Torgovnick) The strategy that I hoped would work was a kind of "trickle-up/trickle-down" approach. At one point, when you had to give perquisites to recruit affirmative action candidates, you could give them to everyone in order to prevent a backlash. As long as the money held out, that worked. But there came a moment when the money did not hold out. Now I advocate simply being aware that the backlash exists; this will help prevent it.

Implications for
Evolving DBAE Practice

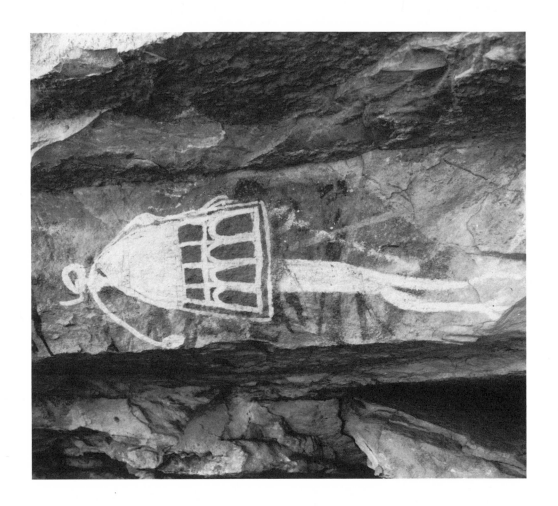

Guardian figure (reclining)
Northern Australia
Date unknown

INTRODUCTION

BRENT WILSON
Professor
School of Visual Arts
Pennsylvania State University
University Park, PA

Brent Wilson opened the session by explaining that each of the speakers would be commenting on a paper that had been delivered in a previous session. Following their presentations, the floor would be open for questions and comments.

The first speaker, Dr. Gil Clark, is professor of Art Education at Indiana University. His work addresses art curriculum theory and development, child development in relationship to art, testing development, and assessment in art education, particularly for gifted students. His many publications include *Educating Artistically Talented Students* and *Understanding Art Testing*. Clark is currently the Director of the Educational Research Information Center Clearinghouse (ERIC), which is supported by the Getty Center.

Dr. Robyn Wasson is manager of the Services Industries Studies Branch in the Vocational Education and Training Program with the Technical and Further Education Training System of Queensland, Australia. As a supervisor of curriculum development and funding allocations for colleges throughout Queensland, Wasson is involved with education in arts, crafts, and social sciences. Her research focus is the interface of art, anthropology, and education. Previously, Wasson was a professor at Ohio State University and a faculty member in the Ohio Partnership, the regional staff development institute.

Dr. Judith Stein is adjunct curator at the Pennsylvania Academy of the Fine Arts and supervisor of the exhibitions of contemporary art in the Morris Gallery. The organizer of over sixty exhibitions, Stein curated the traveling exhibition, "Red Grooms: A Retrospective," as well as "Sentimental Sojourns, Strangers, and Souvenirs" and "Figurative Fifties: New York Figurative Expression in the 1950s." Stein has also served as supervising curator for "The Vital Gesture: Franz Klein in Retrospective" and "Making Their Mark as an Artist: 1970—1985." She is currently at work on a major exhibition of Horace Pippin's work, scheduled to open in 1994.

Jean Detlefsen is an art instructor at Columbus High School in Columbus, Nebraska, which received the 1990 Nebraska Excellence in Art Education Award and was cited by *Redbook* magazine as one of five schools with superior art education programs. As the regional director of the Prairie Visions Institute, Detlefsen has grappled with most of the pressing issues in art education, including multiculturalism.

The final respondent was Vesta Daniel, associate professor in the Department of Art Education at Ohio State University, where she teaches courses in multicultural and multiethnic curriculum development. Daniel is also the coordinator of the Martin Luther King, Jr. Institute for Arts and a faculty member in the Ohio Partnership.

She is the author of the forthcoming *Issues and Approaches to Multicultural and Multi-Ethnic Art Education* and has received many awards, including a National Endowment for the Arts Committee on Multiethnic Concerns award for outstanding contributions in art education and a faculty fellowship from the Mellon Foundation.

RESPONSE TO PAPERS BY ELLEN DISSANAYAKE MARCIA MUELDER EATON, AND JUNE KING McFEE

GILBERT CLARK
Professor
Department of Art Education
Indiana University
Bloomington, IN

Gilbert Clark's task was to respond to presentations made by three speakers of highly diverse backgrounds, Marcia Eaton, June King McFee, and Ellen Dissanayake. Beginning with Eaton, Clark noted that he was particularly impressed by her linguistic metaphor that suggested we need "native speakers," people who are fluent in the art of another culture, to act as "translators" or guides to their art. Her second major point was equally significant: that we need to develop "deep fluency" in our own culture. Clark believes that discipline-based art education helps teachers and students achieve that "deep fluency" in the visual arts. Eaton's third assertion was that educators should strive to produce fluent speakers in as many cultures as possible. Again, Clark was convinced that DBAE contributes to this goal because it can address the arts of many cultures.

Clark felt that McFee's proposal, that art students be exposed to the sociocultural insights of anthropology, sociology, and psychology, was "a big order" and not a particularly practical one. Her demand that teachers deny, reject, or ignore their own cultural backgrounds "is unrealistic and wrong-minded," inasmuch as no one can entirely transcend his or her background. As Eaton pointed out, "it is not wrong to be our cultural selves, it is inevitable." Similarly, a teacher can try, but will not always succeed, in understanding fully the cultural background of every student.

Nevertheless, Clark observed, McFee has drawn attention to a number of important goals to which teachers should aspire, including an emphasis on art as cultural communication; the consideration of how art functions in a culture; and the study of how art is bounded and defined by cultural assumptions.

Clark reported being "bowled over" by Dissanayake's reference to a "paleoanthropsychobiological" approach, but was relieved to hear it rephrased as "species-centric." Of the three presentations, Clark identified with Dissanayake's concerns most closely and found her argument for the common biological heritage of all humans powerful and convincing. He agreed with her assertion that cultural differences, including those reflected in art making, are actually a recent phenomenon in human history.

Dissanayake's historical analysis also appealed to Clark, who agreed that, in contrast to tradition-reinforcing and socially conceived art of premodern societies, modern art embodies an

ideology of personal expression, individualism, and originality. While the sensibilities reflected in modern art can be communicated to students, so can other qualities and values more typical of premodern art. The extraordinary and transcendent, the mystical, the communal can all be explored in celebrations, ceremonies, festivals, and collaborative art-making projects, such as murals and plays. The development of cultural sensitivity through these means is more "attainable, reasonable, and defensible . . . than multicultural teaching as defined by McFee."

Clark believes that much of what was being advocated by these three scholars is actually being practiced by responsible educators. The Getty Center for Education in the Arts has been a leader in the effort through their production of the Multicultural Art Print Series and other materials. Similarly, groups such as UNICEF have long championed the kind of species-centric approach to art and education described by Dissanayake.

The three papers, however, did call attention to certain educational obligations that need to be met. Special efforts on the part of teachers will be required to learn and teach the art and culture of diverse groups without patronizing or romanticizing those groups. Clark maintained that as teachers move away from holiday-centered art activities and projects and toward content-based study of diverse art forms, they will be embracing many of the goals of both multicultural and discipline-based art education as they originally were conceived.

RESPONSE TO PAPERS BY RACHEL MASON, F. GRAEME CHALMERS, AND ALFRED QUIROZ

ROBYN F. WASSON
Manager
Service Industries Studies Branch
Technical and Further Education, Training, and Employment
Queensland, Australia

Robyn Wasson began by discussing Rachel Mason's paper, which provided a broad overview of the history of multicultural education in the United Kingdom and a typology of existing approaches based on the work of James Banks. The presentation, in which the author was positioned "outside the narrative in an objectified stance," left Wasson with a number of unanswered questions about how the national consensus and solutions were arrived at in the United Kingdom. Are questions of racism, and therefore national remedial programs to address them, seen as only the domain of White teachers and students? Why was the "transformational," rather than the "social action," approach to multiculturalism chosen for the national curriculum? Above all, asked Wasson, "what is it about the new national art curriculum that is capable of addressing the issues, concerns, and opportunities surrounding cultural diversity?"

Wasson noted that Graeme Chalmers confronted the question of how DBAE responds to cultural diversity head on and she finds the answer encouraging. However, he identified certain criteria that DBAE educators must keep in mind, such as the need to focus on art as "shared experience," the need to recognize the values and standards of art production in all cultures, the need to recognize the arts as agents of cultural transmission, the need to accept that "no racial, cultural, or national group makes art that is superior to another's," and the need to recognize that all students, regardless of background, have a right to be respected.

Alfred Quiroz, continued Wasson, gave a compelling testimonial on the ways in which cultural diversity has affected his own art. By describing the social and political context of his development as an artist, he has connected his work and life to that of many others of his generation, and suggests that the "new recognition" being afforded minority artists may be somewhat suspect. Quiroz provided an eloquent argument for why more teachers and role models are needed for young, culturally diverse artists, and why stereotyping and tokenism of any kind is damaging to an artist's life and work.

These three presentations make it clear that "we need to move beyond rhetoric and

tokenism in multicultural education to the transformational and social action approach." This includes not only using diverse content, but identifying and utilizing culturally specific ways of learning about and experiencing art. Wasson's own work with the Ohio Partnership has convinced her that DBAE is more than capable of responding fully and effectively to the demands of cultural diversity. However, she noted, "opening the door is one thing, stepping through it another." Now that the theoretical basis for this enterprise is in place, what is needed is the commitment, passion, and energy to make it a reality.

RESPONSE TO PAPERS BY ALAN WALLACH, ROBERT STORR, LISA CORRIN, AND FRED WILSON

JUDITH STEIN
Adjunct Curator
Pennsylvania Academy of the Fine Arts
Philadelphia, PA

The speakers Judith Stein was to comment on had all addressed the issue of multiculturalism within the context of the museum. Alan Wallach, as a theoretician and historian, analyzed how revisionist art history had opened up the possibility of institutional change. Robert Storr and Lisa Corrin, acting as curators, and Fred Wilson, an installation artist, provided examples of culturally diverse practice within museums. Stein suggested that the presentations of the curators could be considered as responses to the challenges outlined by Wallach's paper.

In "Revisionist Art History and the Challenge of Cultural Diversity," Wallach compares traditional art history, based on connoisseurship, iconography, and formal analysis, to revisionist art history, which offers "a critique of the notion of the work of art as possessing universal or transcendent meaning." To demonstrate the differences between the two approaches, Wallach examined a recent exhibition at the National Gallery focused on John Singer Sargent's *El Jaleo,* the portrayal of a flamenco dancer and her Gypsy musicians. He faulted the show for perpetrating a naive, Eurocentric "celebration of the 'exotic'

that failed to examine critically the various cultural myths Sargent drew on."

Stein, however, was unsure about how revisionist art history would have changed this presentation. Should the National Gallery not have organized the show at all? Should they have provided didactic signage critiquing the meanings "inscribed" in the work? Should they have paired the show with a photographic essay on contemporary Gypsies that revealed the poverty and prejudice they face?

Wallach asserted that "a multiculturalist art history implies a program of radical democratization: the undermining of established cultural hierarchies, the redistribution of cultural power, the definition of basic terms beginning with the term 'art.'" But, Stein wondered, as traditional art history is subjected to "the corrective cleaning of 'radical democratization,'" what will be left of the elements of that tradition that have nourished generations of artists, regardless of color or race? She cited as a case in point the African-American painter Jack Whitten, who noted that he was "a great believer in art history: Art history not only roots me; art history serves as launching pad for me. I've had to go through the West—confront Western civilization. In the process, I've discovered Africa as the root of my being."

Although Stein recognized the short-range "chilling effect" of the current conservative

climate on museum practice, she was optimistic that there would be constructive change in the long run. As Storr pointed out in his paper "Make It Real: Notes on Pluralism, Empirical Criticism, and the Present Moment," "Despite the present narrowness of much cultural debate . . . the tense pluralism that is the common fact of our existence will inevitably be recognized as *the* positive force in an evolving . . . artistic tradition."

Storr argued that political correctness is the "pink herring" with which the right has tarred the "diverse interests and diverging approaches represented by the term *multiculturalism*" and that it amounts to "bigotry by abbreviation." The epithetical use of labels like "feminist" or "Black artist" carries the discriminatory implication that the labeler knows just what to expect from such artists because they happen to know a single fact about them. Yet, Storr insists, cultural identity is one of the most complex factors affecting an artist's work: "To expect certain kinds of work from artists because they are women, Native American, Jewish, or African American . . . is the very essence of prejudice and the same."

While some African-American artists consciously forge their aesthetic identity from their ethnic or racial heritage, others work in international abstract modes. To appreciate their work, one must think about how they use common cultural property and, given their background and intentions, alter it. These, noted Stein, are the artists "who have the hardest time, the ones whose work doesn't look Black."

Wallach called for a "radical democratization" of museum practice and Storr looked ahead to a time when curators would focus on "the manifest breadth and richness of pluralist culture." Corrin's description of Wilson's installation indicates that this exhibition attempted to do both by raising the questions: Who are the experts? What do our audiences want to know? However, from her perspective as a curator at one of the nation's oldest and most staid art museums, the Pennsylvania Academy of the Fine Arts, Stein did not expect to see such novel approaches at major institutions like the National Gallery any time soon.

Stein concluded by noting that "change is scary." But it is also exhilarating and renewing. She believed that major changes would be seen in museums given time, and that, with "thinkers and practitioners like Wallach, Storr, Corrin, and Wilson, the pace is quickening."

RESPONSE TO PAPER BY MICHAEL DAY

JEAN DETLEFSEN
Instructor
Columbus High School
Columbus, NE

Jean Detlefsen noted that Michael Day's paper exhibited "a bit of impatience about the need to defend or explain DBAE" in its lengthy defense of DBAE's inclusion of cultural and social issues. Day noted that DBAE maintains its dynamic character because it is grounded in disciplines that are themselves constantly changing to address pluralism, politics, gender, race, and other areas of concern.

Day also provided examples of DBAE art instructional sets based on the art of Native American, African, and other cultures. However, this section of his presentation raised for Detlefsen the critical question of how theory is translated into practice. How, she wondered, did the examples provided by Day fulfill the reasons for embracing culturally diverse art, such as gaining a deeper understanding of the world, fostering feelings of cultural belonging, or developing new insights into the customs, beliefs, and values of others? How do they meet the fundamental goal of art education as identified by Day, that is, the "development of students' abilities to understand and appreciate art?"

In addition to the problems with DBAE cited by Day, Detlefsen would add concern about the selection of what is to be taught and why: "What do I want a student to learn from this lesson? How does this lesson relate to the student's life? What is the meaning of this work? How will I know when I am trivializing a work, a culture, or a concept? How should theory move into practice?"

Detlefsen concluded that she agreed with Day's conviction that DBAE was worthwhile because both teachers and students can learn from it and enrich their own lives: "The payoff is in the enrichment of life that causes children and young people to be more interested, ask questions, offer their own views, and enjoy learning."

RESPONSE TO PAPERS BY BERNICE JOHNSON REAGON, CARL GRANT AND CHRISTINE SLEETER, AND MARIANNA TORGOVNICK

VESTA A.H. DANIEL
Associate Professor
Department of Art
Ohio State University
Columbus, OH

Vesta Daniel began by noting that, in singing the Methodist hymn "Father, I Stretch My Hand to Thee" in her keynote address, Bernice Reagon was daring her audience to "reach for a riskier personal and/or group experience, requiring that we bring something of ourselves to the act of experiencing." The experience Reagon provided was one of listening, hearing, feeling, relating, emoting, and translating—all actions that influence the four disciplines of DBAE.

Although these actions may seem familiar, Reagon suggested that they may take place within unfamiliar systems and under a range of circumstances. Listening, for example, may be active or passive, and may include physical activity with parts of the body other than the ears. Listening can take place in contexts, such as a concert, that demand certain behavior and may be preceded by other activities, such as the gathering of people, and the bristling, chattering, and preconcert restlessness of the general audience. Hearing includes the sensitivity to nuances, such as a breath taken by a singer in the middle of a phrase, a sound that is as much a part of the music as are the notes.

Translating is part of the process of comprehending. It is the transformation of formal elements, such as meter or pitch, or metaphor and symbol, into personal realities or behaviors, such as body language. All of these activities, which take place during a musical experience, reinforce Reagon's recommendation that multiple "experience systems" must be addressed when teaching and talking about art. The DBAE strategies of the future must acknowledge multiple, simultaneous experiences as a normal feature of the aesthetic experience.

At the practical level, this means that instructors must recognize that there is value in the idiosyncratic nature of one's personal interaction with art. Daniel then offered the following two suggestions toward this end:

1. Teachers should provide students with critical exercises that help them recognize their idiosyncratic or ethnically specific experience of artworks.

2. Teachers should introduce and illustrate the notion that traditional standards of excellence can be challenged in order to reach a broader understanding of art.

If DBAE is to loosen the stranglehold that traditional education has had on the minds of teachers and students, suggested Daniel, it must offer culturally diverse content. Only then will DBAE figure prominently in the long process of cultural transformation intended to foster better thinkers and problem-solvers.

Turning to the paper presented by Grant and Sleeter, Daniel noted that they had provided a clear account of the history of multicultural education in the United States, with the omission of the important work by James Banks. She reemphasized their point that multicultural education was a response to demands made by the African-American community during the civil rights movement. Its proponents demanded the right to "be recognized, to be included, to be valued . . . to be free of educational paternalism. It was not intended to develop endless ways of saying 'I'm O.K., you're O.K.'"

Grant and Sleeter reminded their audience that existing curricula do not challenge racism, and are, in fact, characterized by "blatant Whiteness." However, Daniel noted, there is no plan offered for addressing this problem and its destructive potential. This "nonspecific, all accommodating" character of the concept of multiculturalism is its greatest problem, and DBAE risks inheriting this problem if it "swallows multiculturalism whole." This approach might leave historically disenfranchised groups, such as African, Native, Hispanic, and Asian Americans "lost in the throng."

In their description of the five most common approaches to multicultural education, Grant and Sleeter favored "multiculturalism and social reconstruction, which begins with contemporary social justice issues that cut across diverse groups and uses disciplinary knowledge to examine them and affect change." In the discussion of themes and the artworks that address these themes, Daniel recommended certain guidelines:

1. Possibly unfamiliar art, such as Asian American works, should not be studied as a monolithic body of work.

2. Teachers should avoid the trap of attaching traditional, mystical, or religious meaning to all art that is not understood.

3. Teaching strategies should be opened up to include the works of culturally disenfranchised and ethnically astute scholars.

4. Local interests should be connected to world interests and art.

Daniel concluded that an aggressive attempt to ally multiculturalism to overall education at the level of policy, curriculum content, and teacher behavior might be more fruitful than the

current limited focus on working multiculturalism into DBAE. Additionally, the clarification of the historical origins of multiculturalism as a strategy for combating racism might move the DBAE-multiculturalism debate "beyond rhetoric to the development of positive and creative plans."

Daniel noted that Torgovnick commented from her perspective as an English professor on the myth of a common heritage perpetuated by the existence of a literary canon. What Torgovnick referred to as "canon expansion" is called in other educational fields "curriculum infusion" or "inclusion," a process that has been vigorously opposed by conservatives as a threat to the "national cultural heritage" and an invitation to cultural conflict. Other objections that have been raised to "curriculum infusion" are that it requires that teachers be knowledgeable about a number of different cultures, and that the primacy of European history and contributions will be diminished.

Torgovnick addressed several of these concerns by noting that her department continues to teach the traditional subjects as well as new ones. However, Daniel was not sure whether that statement implied that the traditionally omitted material was "added" on and relegated to permanent guest status. Although she was not against the creation of new courses, Daniel preferred that DBAE weave missing content into the structure of existing courses: "The further marginalization of previously mismanaged cultural and ethnic content is not O.K." Aside from this point, Daniel proposed that DBAE could learn much from the discipline of literature about using culturally based criticism in the analysis of various works.

Interdisciplinarity, as Torgovnick described it, is something that art educators are deeply engaged in, concluded Daniel: "At a time when racism is vigorous, when the police may no longer be your friends, when the definition of minority is becoming a source of confusion . . . we may need to look into sociology, psychology, or anthropology . . . to decipher what those realities have to do with art, how it is taught, and how it is received."

INTERACTIVE PANEL WITH FIFTH PLENARY SESSION SPEAKERS

GILBERT CLARK

VESTA A.H. DANIEL

JEAN DETLEFSEN

JUDITH STEIN

ROBYN F. WASSON

BRENT WILSON

QUESTIONS AND ANSWERS

Q: (From the floor) I would like to return to a subject that has been mentioned before: token-ism. I was glad to hear lesbians and gay men mentioned at the opening of this conference, but since then gay and lesbian issues have not been raised. It is as if the speakers and organizers do not understand the connection between gay and lesbian concerns and multiculturalism. At least this would appear to be the case since no speaker has identified him or herself as gay or lesbian. No one in this room would presume to hold a conference on racism without people of color or on sexism without women. Why have there been no gay or lesbian presenters here? It may be that the organizers assumed that their concerns could be subsumed under the general heading of "diversity," but each oppressed group endures specific forms of repression and raises different questions.

In order stimulate some discussion on this topic, I would like to share some questions that have occurred to me over the last few days.

1. If one of the goals of multiculturalism is to build self- esteem in viewers of art, would it be appropriate to add to the labels on works by Michelangelo, Cellini, and Caravaggio the fact that they were gay?

2. Would it be valid to have exhibitions of art by men who love men, or women who love women?

3. What are the components of gay sensibility or gay aesthetics and what forms do they take?

4. How does "invisibility" affect the artistic process? No one ever asks an African-American artist if he is "out" to his colleagues.

5. How do art educators deal with the fact that homophobia is one of the last societally sanctioned forms of oppression?

A: (Vesta Daniel) I want to remind you that the history of the issues you are discussing, from the point of view of those who have been part of the struggle for equality, follows a familiar pattern. You are now experiencing the early phases of a predictable, evolutionary process, one that is well worth pursuing. I would advise you to keep making your views known and to recall that when multiculturalism was formed as a movement, its focus was race. In the course of its development the movement has expanded to include other forms of diversity, including sexual preference.

There are, by the way, African-American people who are not "out" and have the choice to be either "in" or "out."

A: (Judith Stein) The questions you ask are germane and complex. As a curator I was involved in an exhibition of Bay Area art. When it was relevant, as in the case of two artists who had been lovers, their homosexuality was mentioned because it was a part of their identity that they wished to be known. But as a curator of twentieth-century art, I deal with the work of many living artists. Is it appropriate to "out" them if they have not, themselves, made their homosexuality known? In the case of dead artists, this is less of an issue. Several important exhibitions, such as one on Marsden Hartley, have made the artist's sexuality part of the interpretive material because it deepens one's understanding of the work. This is a delicate issue and curators must proceed cautiously.

A: (Comment by Terry Barrett from the floor) There is a lot of interesting and significant art made by activists from ACT UP and other groups that art teachers are afraid to deal with because they are uncomfortable with it themselves.

I would like to point out the parallel between DBAE and what has happened with art in the national curriculum. The subject areas in art are culturally diverse as a matter of policy, but the question of equity and social justice is cross-cur-

ricular. Interestingly, the subject areas that have been most heavily debated have been history and art history.

Q: (Martin Rosenberg) I would like to return to the point that Vesta Daniel made: that multiculturalism as a concept can be too all-accommodating, too diluting, and DBAE could fall into this trap if it swallowed multiculturalism whole.

A: (Vesta Daniel) In 1973 or 1974, when I started working with multiculturalism in Chicago, one of my jobs was with the Office of Urban and Ethnic Education, where I worked with teachers, parents, and children. Initially, most of these were African American. But over the course of the years, as I began teaching at a university, I noticed that the original notion of multiculturalism was being stretched to include everybody. There were schools in Chicago with eighty ethnic groups in the student body, and the teachers, understandably, would come to us for advice on how to deal with all of them. We had to begin to make decisions about how to talk about lack of representation and disfranchisement, and how to develop models that would allow them to incorporate previously excluded information in any framework.

Today my colleagues are saying to me "you cannot say that it is equitable that specific groups should be given more attention than others." But I say "yes I can." I know that there are certain

groups that are always going to be represented, either covertly or overtly, because they represent the standard or model. Multiculturalism is diluted. It has changed a great deal since 1965, so teachers are saying "what do we do in January and February and March so that everyone is happy." We need to look at that situation.

A: (Gilbert Clark) I would like to endorse that. In the last couple of days I have been wondering how many school hours are devoted to art, and given that limitation, how the demand that all cultures be represented coequally can possibly be met.

A: (Robyn Wasson) This relates to the earlier discussion of trivialization. I do not think it matters how many cultures one covers, only whether the ones that are covered are handled with respect.

A: (Brent Wilson) I have called this one of the "plagues of pluralism." If we are just trying to cover every culture, we are bound to fail. There has to be another starting point.

Q: (From the floor) Given this country's Eurocentric dominance, don't we have a special responsibility to deal with African Americans and Native Americans? American history, to a large extent stems from the relationships between these groups and the dominant culture.

A: (Vesta Daniel) I read an article analyzing *The Adventures of Huckleberry Finn* that argued that, although it has been banned in many schools because the word *nigger* is used more than 200 times, a close reading of the cadence and speech of Huck, and of much of the book, was based upon that of a young Black boy that Twain had met. The author also goes on to say that much American literature seems to be reflecting, in some way, the relationship of this nation to African American people, even if the theme is not, overtly, African American. It is an interesting idea but very problematic, because the author is suggesting that, since this offensive language has an African-American origin "it's O.K.," and this text ought to be reintroduced in the schools. This is an aspect of multiculturalism that can slip right past one, because it looks like advocacy.

A: (Comment by Marianna Torgovnick from the floor) The incorporation of multicultural material in literature courses usually follows a pattern. Its first phase is tokenism, where one work is introduced in a self-conscious way. Next, whole courses are devoted to, for example, African-American literature, which is a ghettoizing approach. Many departments are moving beyond this approach, including works by Black authors in general literature courses when they seem necessary, or providing specialized courses in African-American women's literature, slave literature, novels, etc. This is a multiple model that I prefer. A Black author may not be represented in

a Victorian literature survey, but issues of race certainly would be.

A: (Comment by Carl Grant from the floor) I would hope that we would not reduce multiculturalism to particular curricular material. It is broader than that, involving philosophy, material, and instruction techniques.

A: (Gilbert Clark) Although I agree in principle, as a teacher I must insist that materials are critically important.

Q: (From the floor) I would like to address the representational model of inclusion, which I believe is only partially useful. We need to make more of a distinction between ethnic studies, where single groups are examined, and multiculturalism, which focuses on society as a system. We also need to think more carefully about the relational aspects of identity. I feel that at this conference notions of identity have been objectified. As Jesse Jackson has said, "the study of the history of slavery is also the study of the history of the babies of the slave master." I urge a more relational analysis of the way identities are constructed in history.

Comment: (From the floor) Even if we could develop the perfect curriculum materials and make all the right choices in the classroom, students also live in a wider community. Our challenge, therefore, is to find ways of impacting that community as a whole and of carrying multiculturalism beyond the classroom or the art department.

A: (Brent Wilson) This is an extremely important point and relates to the central question of how art education can further social change. Have schools in the past been agents for social reconstruction? If not, it is possible that they might be in the future?

A: (Gilbert Clark) I remember reading a book as a student entitled *Dare the Schools Build a New Social Order?* It was originally published in the 1930s by George Counts. It is now a required text in five college classes at Indiana University and has been brought back as if it were a brand new offering.

A: (Brent Wilson) Arthur Efland pointed to the fact that planned cities never seem to work, whereas cities that simply grow over time do. I sometimes wonder what kind of society educators would create if they had the power.

Q: (Comment by Claudine Brown from the floor) I was struck by the call for a more relational approach to identity issues. As an African American, a mother, an attorney, a museum educator, my identity is constituted by several different communities. Keeping that in mind, what is the practitioner's approach to these multiple communities?

A: (Jean Detlefsen) What practitioners try to do, first of all, is to work with the student's own background, his or her cultural heritage, and his or her specific community. In a ninth-grade class, the students talk to their family members or someone close to them who will help them identify and recognize the contours of their own cultural community, including the art and artists it contains. They then go to an art survey text and search out some connection. Some can not find their own heritage. There are many Polish Americans in my community and the only connection these students can find in the text is *The Polish Rider* by Rembrandt. This is where the discussion starts about representation and the lack of it.

A: (Robyn Wasson) I think that changing the social order in a community may be too great a demand on art education. Instead, we should be asking if schools can provide alternatives to existing ideologies and give students some grounds for challenging prevailing values and assumptions.

Affinity Group
Summary Reports

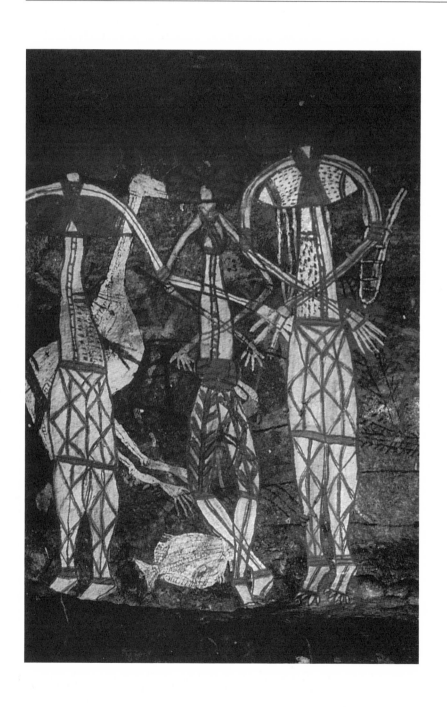

Paintings
Northern Australia
Dates unknown

INTRODUCTION

CLAUDINE K. BROWN

From the comments made by many of the participants, Claudine Brown was sure that the last three days had proved very enlightening and fulfilled many of the goals of the planning committee, including stimulating discussion and interdisciplinary exchange. The conference may not have generated many definitive answers, but Brown was convinced that the group was, at least, closer to finding answers than they were before the conference. The issues being addressed are incredibly complex and simple solutions will not suffice.

Belief systems have been challenged and new professional relationships formed. The only way the conference could have a negative outcome, Brown asserted, was if the participants did not continue their dialogue beyond this forum.

The speakers for this final plenary were reporting on the conclusions of the Affinity Group Breakout Sessions. Catherine Leffler is an elementary school teacher in the Encino Elementary School. Leffler also coordinates the school's computer lab and a community school art gallery that exhibits work by students and professional artists. As the curriculum designer for her school's discipline-based art program, she has conducted discipline-based art education training and presentations for the news media, school board members, and other educators.

Judith Bryant is an art specialist for the Portland public schools, grades 6 through 12, as well as a practicing artist. She taught middle school for nine years and has been a curriculum coordinator for the past six. Ms. Bryant holds a B.F.A. in painting from the University of Oregon and an M.S. in elementary education from Portland State University.

Martin Rosenberg is associate professor of Art History and a member of the women's studies faculty at the University of Nebraska at Omaha. He also serves on the education committee of the College Art Association. In recent years he has focused on bringing the concerns of feminism and cultural diversity to the study of art history. One of the architects of the Prairie Visions consortium, Professor Rosenberg has coordinated the University of Nebraska's preservice program in DBAE.

Enid Zimmerman is professor of Art Education and Gifted and Talented Education at Indiana University, as well as an adjunct women's studies faculty member. Dr. Zimmerman has conducted numerous research and development projects in art education, focusing on curriculum development, multicultural art education, and women's issues.

Janis Norman is an associate professor and chair of the Art Education Department at the University of the Arts in Philadelphia. With more than twenty years of experience teaching and coordinating art programs for students at all levels, Dr. Norman has worked extensively in curriculum development. She is the founder of the Art Education Connection of Greater Kansas City and has produced many presentations and publications on arts advocacy.

Anne P. El-Omami is curator of Education at the Cincinnati Art Museum and holds a B.A. in Art History, a B.F.A. in Art Education, and an M.A. in Art History and Art Education from the University of Nebraska. She has spent two years in Africa and Egypt working toward her Ph.D. in the History of Art and Cultural Anthropology from Northwestern University. Ms. El-Omami has served as a consultant for the National Endowment for the Arts, the Getty Center for Education in the Arts, and *The Journal of Aesthetic Education.*

Peter Pennekamp is vice president of Cultural Programming at National Public Radio's Program Services division. In this capacity he works to spotlight America's wide-ranging cultural mix. Previously he served as the director of the Inter-Arts program of the National Endowment for the Arts and assistant dean of the College of Creative Arts and Humanities at Humboldt State University in California.

ELEMENTARY EDUCATION

RECORDER: Catherine Leffler,
Elementary Teacher/Art Coordinator,
Encino Elementary School, Encino, CA

The elementary educator, who is responsible for implementation, rarely takes part in theory development, and this fact can lead to a polarization between theorists and practitioners. The Affinity Group, however, suggested that the absence of an elementary generalist as presenter or panel member should not be taken as a indicative of the generalist's role in the process of change.

The topics of the discussions arising in the Affinity Group may have been suggested by the formal presentations, but tended to focus on concerns that affect the thinking and practice of elementary teachers in regard to cultural diversity. Not surprisingly, more questions than answers were generated, including the following:

1. What is art?

2. Does the cultural environment in a community and its school affect multicultural art education?

3. What cultures should be included in the curriculum and should these be the cultures in the school or in the nation?

4. How does one become "fluent" in a culture? How does one find bridges to reach this fluency?

5. Is it necessary to address the aesthetics that are unique to a particular culture?

This last question was posed by a Native-American participant who noted that the word "art" does not exist in her language, but is infused in many other concepts, such as "religion," "science," and "family." The group was particularly concerned about whether multicultural education "could be all things to all people," and whether it could be taught according to a formula.

Because teachers are responsible for translating theory into practice, and because changes in the total system must begin at the elementary level, the participants sought special recognition for the problems they face. The generalist teacher must schedule approximately thirteen areas of instruction into one week, as well as deal with drug abuse, AIDS, abused and homeless children, the learning disabled, language problems, and the physically and mentally challenged. One participant noted that society was "like a three-legged stool, with church, the family, and the school each constituting one leg." However, the first two legs are no longer functioning for many students, leaving schools with the sole responsibility for some children's futures.

As practitioners, the participants called for more dialogue with representatives of higher

education. Additionally, it should be noted that many of the elementary educators had attended DBAE institutes and have been implementing superior multicultural art education programs for many years without a published curriculum. Educators, however, will need high-quality instructional materials and curriculum guides if they are to become culturally fluent and enrich their art teaching.

The group briefly identified some of the sensitive issues that can arise in discussions of art and provoke concern from parents, staff, and the community at large. These include religion, education, sexuality and representations of the nude, politics, and sexual orientation. There was also a consensus that agreed-on definitions and structures would help teachers "understand, sharpen, and refine the tenets of multicultural education." In response to this demand, one participant offered a matrix whose horizontal axis consisted of the four disciplines of DBAE and whose vertical axes included elements such as beliefs, values, artifacts, cultural expression, language, and environment.

The successful dynamics of the group's discussion led the participants to institute a network for further discussion and a participant volunteered to assume the responsibility for organizing the network. The group report concluded by urging speedy action, noting that the level of passion among teachers is high, and that the nation does not have the luxury of taking its time.

SECONDARY EDUCATION

RECORDER: Judith Madden Bryant, Art Specialist, Portland Public Schools, Portland, OR

The secondary education group's first of three discussions focused on curriculum development. The key issues, they decided, were how to make curriculum responsive to multicultural education, diverse populations, and learning styles and how to help teachers recognize the biases and preferences that are communicated by their practices, language, and approaches. In discussing these issues, the group discussed the problem of implementing multicultural curricula without trivializing specific cultures. The importance of translating theory into everyday practice, or "trenchology" as one participant put it, was also stressed.

Consensus was reached on a number of points, notably that it is better to teach a few things well, and emphasize the process as much as the product. Participants also agreed on the need for more "models of excellence" and networks for secondary school teachers to share information and ideas. They concluded that interdisciplinary, thematic, and cross-cultural inquiry would expand DBAE and make it more relevant to students and that local resources should be utilized to the extent possible.

During the second meeting, which focused on DBAE's relationship to other disciplines, the secondary school group discussed the teaching of art from a historical and contextual perspective, including the possibility of drawing on concepts from anthropology and psychology. There was some disagreement about the definition of cultural diversity, however, and whether the idea of a totally inclusive curriculum is a reasonable goal. The group concluded that, although an interdisciplinary approach seemed appropriate for DBAE, care should be taken when borrowing from other disciplines so that the focus remains on the unique and valuable role of art.

The group's third meeting was devoted to a discussion of the extent to which art education can or should be an agent for social change. Several participants noted that art education often takes place in an environment that is not supportive of the values and assumptions of DBAE. They concluded that teachers need to think of themselves more as scholars and researchers in the educational process (lifelong learning). They should seek a forum for discussing strategies for implementing DBAE theory in everyday practice. On a final note, they expressed the hope that the Getty Center would continue to sponsor much-needed curriculum development that supports cultural diversity.

HIGHER EDUCATION GROUP A

RECORDER: Martin Rosenberg, Associate Professor of Art History, University of Nebraska, Omaha, NE

The Higher Education Group A identified four major issues for discussion: definitions, goals, context, and implementation.

1. Definitions. The group noted the importance of definitions, as well as the danger of losing the larger issue of multiculturalism in abstractions such as "political correctness." Traditional assumptions about art and art education must be defined and challenged in light of issues of cultural diversity, and the impact of multiculturalism and revisionism on the disciplines of DBAE must be clarified.

2. Goals. To assist in defining goals, DBAE educators should decide "where we want to go." Diverse issues and perspectives must be considered when setting these goals, including ways in which cultures must be considered equal in the context of art education, and whether or not social change should be a major goal of multicultural art education. The entire art education community should be included in the discussion of goals relating to cultural diversity so that a consensus can be achieved.

3. Context. Community values, political dimensions, the culture of schools, and the nature of society all shape the contexts in which art education takes place. Some consideration must also be given to the opposition to multiculturalism that exists in the field and to other new paradigms for art education.

4. Implementation. In the translation of new ideas into classroom practice, new questions must be asked about art. How can the existing questions be reframed to suit a more culturally diverse approach to art? Do new questions mean giving up the Western canon or simply shifting priorities? How should artworks be selected, and how should cultures be compared or treated in relation to one another? Preservice and in-service must be adjusted to reflect the priorities of multiculturalism and the increasingly interdisciplinary approaches to the curriculum.

Among the issues left unresolved by the group were the questions of whether art education should be used as a vehicle for social change, how to guarantee that authentic cultural translation, from a position of "deep fluency," is offered to students, and how value and quality issues should be addressed in a culturally diverse curriculum.

The group concluded with the recommendation that further alliances be forged between higher educational institutions and schools and that professionals should be granted credit for such activity. A similar need exists for partnerships among museums, schools, and universities. A network of people at all levels of art education who are interested in furthering the goals of cultural diversity should be established.

HIGHER EDUCATION GROUP B

RECORDER: Enid Zimmerman, Professor of Art Education, Indiana University, Bloomington, IN

Higher Education Group B began their meetings with a discussion of the cultural roots and biases of the participants. Although the group appeared "monocultural" in the sense that it was composed of White men and women, it was discovered that they represented different sexual orientations, religions, and ethnicities. All shared, however, a dedication to the teaching of art to students of all backgrounds.

There were two issues that the group could not resolve during their discussions. The first concerned the relationship between DBAE and cultural diversity and centered on whether cultural diversity could be added to the existing DBAE paradigm, or if DBAE needed to be radically restructured, in a "paradigm shift," to become culturally diverse. The second issue was one of academic freedom: "Can or should you dictate to a faculty member what he or she should teach or how to behave?" The bulk of the discussions occurred simultaneously in subgroups with the following results:

SUBGROUP 1: FACILITATING THE PARADIGM SHIFT

Because it is not possible to continuously add new materials to the curriculum, subgroup 1 focused on the feasibility of a paradigm shift

within DBAE and the development of art curricula. Current frameworks include the "Royal Academy" approach, the "telephone book" or all-inclusive approach, and the "consumer reports" approach, which argues for the importance of particular works and cultures. The group proposed that a "reflexive critical inquiry model" could be used to modify these frameworks in light of the concerns of cultural diversity. They also suggested that goals and content should be used

1. to facilitate students' study of artworks, and

2. to help teachers make curriculum choices relevant to all their students.

Other suggestions from this group included the development of a pool of "content helpers" or resources in the local community and the articulation of culturally consistent values through aesthetic inquiry, so that "big" questions can be addressed.

SUBGROUP 2: CHANGING THE HIGHER EDUCATION SYSTEM

This subgroup addressed the problem of increasing support for multiculturalism in the college or university setting. Some of their suggestions included the following:

1. Changing the "supply and demand" relationship through active recruitment of diverse students and faculty. This process should begin as early as the middle school years.

2. Encouraging faculty to play strong mentoring roles and create supportive environments for diverse students. This will require modifying traditional practices in higher education, such as tenure review procedures and reward systems, that inhibit the development of a diverse environment.

3. Taking advantage of the expectation in the university community that the art and art education faculties will be nontraditional and the first to initiate and implement changes.

SUBGROUP 3: PRESERVICE TEACHER PREPARATION

Subgroup 3 raised the following concerns:

1. The need to generate support for multicultural education among administrators at all levels.

2. The need for partnerships with experts in the social sciences to help in addressing multicultural issues in class.

3. The importance of encouraging college and university students to "take ownership" of their learning experiences, including bringing their multicultural understandings to bear on the processes of teaching and learning.

4. The need to encourage college and university students to engage in early field experiences with diverse student populations.

SUBGROUP 4: SHAPING THE NEW GENERATION

The key question discussed by this subgroup was: "What kind of art education doctoral students do we need to produce in the next decade?" Future doctorates will be earned in a new educational climate, where an emphasis on formalism in art has given way to multicultural, feminist, economic, and political analyses of artworks. The canon has been expanded to include performance, installation, video, and other new art forms. The group offered the following as a key question for further discussion and debate: "How do we assure that the new generation of doctoral candidates in art education will be thoroughly grounded enough in the works of art that are the focus of art education, and at the same time be well grounded in criticism, ethnography, semiotics, philosophy, psychology, and history that it will allow them to interpret these works fully and comprehensively?"

A related question was whether there should be a multicultural requirement at the doctoral level and whether doctoral candidates should serve an internship in a multicultural context. The group concluded that there is a risk that future doctorates will be unprepared for the cultural, technical, and theoretical challenges they will be expected to meet; therefore, immediate action is necessary.

After each of the four groups summarized their findings, it was agreed that the discussion exemplified a key tenet of multicultural education: "No one can do it alone; we all need each other." To address the concerns raised by the groups, collaborations among many people of different backgrounds, in a variety of contexts, will be needed and necessary.

SUPERVISION AND ADMINISTRATION

RECORDER: Janis Norman, Associate Professor and Chair, Art Education Department, University of the Arts, Philadelphia, PA

Before reporting the conclusions of the Supervision and Administration Affinity Group meetings, the participants called for a clarification of the unique role they play in the balancing of theory and practice in education. In the course of their discussions, the group identified two types of issues, which they called "Smaller Issues" and "Larger Issues."

The smaller issues included the following:

1. The need for translators who can help teachers interpret the meanings of diverse art with authenticity and passion. Related to this is the need for quality in the level of instruction and in the choice of culturally diverse materials. Who should be responsible for choosing such materials?

2. The fact that there is a reluctance to change within education and that most teachers will choose to "stay where they are."

3. While the need for serious attention to cultural diversity was unanimously supported, there remain questions about how to teach a multicultural curriculum with integrity and depth.

4. In-service, and the time to implement it, is in short supply.

5. Teachers, who feel they are "doing the best they can," feel frustration when they realize there is so much more to do.

The larger issues, which were many and daunting, included the following:

1. Cultural diversity must not only be taught, but must also be practiced in our schools through curriculum design, hiring practices, and sensitivity to the cultural backgrounds and learning styles of students. To make this happen we must know what is right, embrace it, and act on it.

2. The two best prospects for change are preservice and in-service. First, higher education must become a significant partner in the push for cultural diversity, through recruitment, curriculum, and tenure and hiring practices. Second, professional development, to reach teachers already in the field, must be redirected toward multicultural education.

3. Because the arts are often a magnet for students who are outside the mainstream—i.e., ESL students and the mentally and physically challenged—art educators face enormous pressures.

4. Because children must enter school ready to learn, the Getty Center should make an official endorsement of art education in early childhood learning.

5. To implement multicultural education at the level recommended by Banks and others will require a major restructuring of the educational system.

In conclusion, the group unanimously agreed that there must be a widespread commitment to change: "This conference deals with the 'what,' the next step is to deal with the 'how.'"

MUSEUM EDUCATION

RECORDER: Anne P. El-Omami, Curator of Education, The Cincinnati Art Museum, Cincinnati, OH

The Museum Education affinity group consistently returned to what they identified as the primary issue: power and authority, its manifestations and constraints, and its impact on aesthetics, taste, value, and history. Museum educators, who must work from permanent collections, do not have the choices afforded classroom teachers in regard to multicultural source materials. Thus, diversity must be achieved by raising issues and challenging viewpoints, rather than exclusively through the imagery and content available.

There were certain areas of disagreement in the group. The first was over whether multicultural education was necessarily "transgressive" or "subversive." The second was that racism, which lies at the heart of issues of power and authority, was not directly addressed during the third Issues Seminar. Last, hiring practices continue to be a source of contention, with some participants insisting that there are not enough qualified people of color to hire, while another group felt that the criteria for designating someone "qualified" was deliberately exclusive and guaranteed few qualified minorities.

Among the conclusions and recommendations made by the group were:

1. Trustees and administrators should provide opportunities for museum professionals to address directly issues of power and authority within the traditional museum structure.

2. Museum education has done the most to raise the issue of diversity in art museums, but the issue often ends there. Systemic changes in the structure and procedures of museums must be initiated to encourage diverse perspectives. Professional arenas must be created to address the need for change throughout the museum community.

3. Museum directors must develop long-range plans to serve as "brokers" of cultural resources to teachers and educational institutions, as well as long-range plans for implementing cultural diversity.

CROSS-REPRESENTATIVE

RECORDER: Peter Pennekamp,
Vice President for Cultural Programs,
National Public Radio, Washington, D.C.

RECOMMENDATIONS:

1. Assess curriculum materials to determine if different, and a greater variety of, materials are needed. The goal is to ensure that substantive and usable materials are available for use in pre-service, primary, and secondary education.

2. Provide staff development to support use of materials.

3. Scholars should be aware of the realities of the classroom. Don't put down practicing teachers!

4. Increase collaboration with social scientists and all other knowledgeable people when appropriate, and generally promote interdisciplinary teaching.

5. Encourage teachers wherever and whenever possible to increase students' tolerance and appreciation of diverse art. Teachers should be encouraged to see diversity as enriching; lack of diversity as boring.

6. Include artifacts and information from a broad range of art worlds. Examples given include: carnivals, advertising, rock concerts, graffiti, design, comic books, architecture, film and video, murals, radio.

7. Make more of a connection between the visual and performing arts.

8. Develop a booklet of success stories on implementing DBAE and diversity in the classroom.

9. Training in critical visual skills about mass media should be included as part of the art canon.

10. Determine ways to better use the capabilities of living resources, e.g., artists-in-residence, in classrooms for substantive, multicultural, educational value.

11. Teachers should be encouraged to use the materials creatively, as well as to be responsible to facts and traditions. (Fred Wilson inspired).

ISSUES UNRESOLVED:

1. There is art that can't be taught without raising social, psychological, or political problems: Eliot, Pound, Guston, Goya. Does "nasty" art belong in the precollege classroom?

2. Where does cultural "authority" reside? Who can and should speak for communities and traditions not now represented, or poorly represented?

3. The inclusion of a full range of American cultures must be covered in K–12, not in any given year.

CLOSING STATEMENT

THANDIWEE MICHAEL KENDALL
Program Officer
Getty Center for Education in the Arts
Santa Monica, CA

Thandiwee Michael Kendall began her presentation by thanking the participants, the Getty Trust and its staff, Pacific Visions, and the other technical and support personnel who contributed to the Third Issues Seminar. She noted that her own decision to pursue a career in education was reinforced and encapsulated in the statement, "If you choose to be in education, you choose to serve." Kendall believed that service, in this context, meant service "to students, to communities, to parents, and most of all, to yourself, in making a better world."

Kendall came to Getty with "no expectations . . . that is, in part, what *service* means." This does not imply, however, that one is not disappointed at times; it implies that one is as attached to the process that contributes to the outcome as one is to the actual outcome. Like many of the participants, Kendall has lived and worked in a variety of communities, including some of the worst ghettos in the nation, "both the impoverished and the very affluent ones." She has also known and participated in strong feminist traditions, womanly traditions of the African-American community, as well as efforts for gay and lesbian rights. Her experience includes involvement with many people who have realized their own potential to affect change and who understand the power of solidarity.

To illustrate the true meaning of solidarity, Kendall cited a story related by Frank Judd, who left Oxfam to join the House of Lords. Judd recalled meeting the Bishop of San Cristobal who had worked extensively with Mexican Indians and Guatemalan refugees. The Bishop asked Judd if Oxfam really had a relationship of equality with the people it serves. Solidarity, the Bishop explained, is a process of identification at the level of the individual, group, and community. Solidarity, he observed, is "the modern meaning of charity."

True solidarity is a process of enabling people to achieve their own goals and to discover and use their own talents, creativity, and powers of reason. As the movement for cultural diversity grows, it is important to keep this point in mind and to ask the question "Are we in solidarity with the communities we say we serve?" To be able to answer this question in the affirmative involves "experiencing life with the people, going into their schools, walking their streets and communities even where you may not be comfortable."

Cultural diversity is not a new issue, Kendall noted, but it has gained attention in recent years. This increased attention is due to changing

patterns of international migration and recent political and social transformations, including those Kendall witnessed firsthand in South Africa on the eve of the March 1992 referendum vote. Cultural diversity is a matter of human rights. In fact, the 1978 International Covenant of Human Rights states explicitly that everyone has a right to participate in the cultural life of the community. Cultural diversity is also a question of gay rights and rights for racial groups: "Homophobia, sexism, ageism, ableism and disableism are all issues that must be more extensively addressed."

It is not the task of the Third Issues Seminar to cover all of these issues, Kendall continued, but to serve as a catalyst for the participants, so that they can better address these problems in their own classrooms and communities. This mission has led the Getty Center to call attention to the need for new curricula, materials, and images in the classroom, and to question the entire notion of "values" and how they are articulated and communicated. Teachers, Kendall added, have too long wrestled alone with all of these issues in very immediate ways.

While many of those present were in Arizona for the 1992 NAEA conference, Kendall recalled, riots erupted in Los Angeles following the Rodney King verdict. Ironically, Kendall found herself fleeing from her apartment on the edge of Koreatown with a greater fear than she had ever experienced in South Africa: "Here in a country where we say we are committed to the notions of equity and access . . . people are dying for change." Rodney King's plea "Can't we all get along?" went to the heart of the outcomes we seek from multicultural education. Kendall was convinced that a genuine commitment to social activism implies a matching commitment to social reconciliation.

In the aftermath of the riots, many people looked again at schools—their needs, their successes, and their failures. One of the most immediate ways of changing attitudes is to change the people who represent those attitudes. Unfortunately, the data suggest that the majority of new teachers are White females who want to teach in predominantly White suburban schools, while the majority of students are children of color from the inner city. To address this critical imbalance we need a comprehensive program of change, including an aggressive action to recruit new people into education at the undergraduate and postgraduate level.

In essence, Kendall suggested, this entire conference is about wedding educational programs to human rights. What teachers do in the classroom has a tremendous impact on the lives of their students; it is critical that each person confront her or his own biases, a process that can be the beginning of major changes. But as we

"look into the mirror," she proposed, it should be with the true notion of solidarity in mind and with a willingness to explore what we all have in common.

Kendall concluded by noting that change takes place within, as well as outside of, institutions. Teachers and administrators have as much a role in changing art education as does the Getty Center. She urged all of those present to call any and all of the program officers at the Getty Center and keep them apprised of their needs and progress: "We need you working on the outside, pushing to create change, as we push the walls from the inside."

References
Resources
Participants

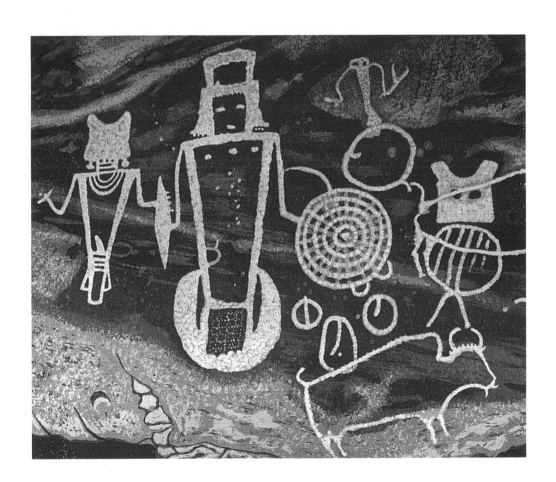

Petroglyph
Fremont culture, Colorado
Date unknown

REFERENCES

Abel, E., ed. 1982. *Writing and Sexual Difference*. Chicago: University of Chicago Press.

Alexander, K. and M. D. Day. 1991. *Discipline-based Art Education: A Curriculum Sampler*. Santa Monica, CA: Getty Center for Education in the Arts.

Allport, G. W. 1954. *The Nature of Prejudice*. New York: Addison-Wesley.

Altbach, P. G. and J. Wang. 1989. *Foreign Students and International Study: Bibliography and Analysis, 1984–1988*. Lanham, MD: University Press of America.

American Association of Museums. 1991. *Excellence and Equity: Education and the Public Dimension of Museums*. Washington, DC: American Association of Museums.

Association of Art Museum Directors. 1992. *Different Voices: A Social, Cultural, and Historical Framework for Change in the American Art Museum*. Washington, DC: Association of Art Museum Directors.

Banks, J. 1991. "A curriculum for empowerment in action and change," ch. 5 in C. Sleeter, ed., *Empowerment through Multicultural Education*. Albany: SUNY Press.

Baptiste, H. P. 1979. *Multicultural Education: A Synopsis*. Lanham, MD: University Press of America.

Baptiste, H. P. and M. L. Baptiste. 1979. *Developing the Multicultural Process in Classroom Instruction: Competencies for Teachers*. Lanham, MD: University Press of America.

Barrett, T. and S. Rab. 1990. "Twelve high school students, a teacher, a professor, and Robert Mapplethorpe's photographs: Exploring cultural difference through controversial art." *Journal of Multicultural and Cross-cultural Research in Art Education* 8 (1): 4–17.

Bennett, C. I. 1990. *Comprehensive Multicultural Education: Theory and Practice*. Boston: Allyn and Bacon.

Berger, J. 1972. *Ways of Seeing*. New York: Penguin Books:

Bodinger-DeUriate, C. and A. R. Sancho. 1992. *Hate Crime: Sourcebook for Schools*. Philadelphia: Research for Better Schools.

Blandy, D. and C. Congdon, eds. 1987. *Art in a Democracy*. New York: Teachers College Press.

Clark, G. and E. Zimmerman. 1987. *Resources for Educating Artistically Talented Students*. Syracuse, NY: Syracuse University Press.

Clark, G., M. D. Day, and W. D. Greer. 1987. "Discipline-based Art Education: Becoming Students of Art," pp. 129–193 in R. A. Smith (ed.) *Discipline-based Art Education: Origins, Meaning, and Development*. Chicago: University of Illinois Press.

Clark, T. J. 1973a. *The Absolute Bourgeois*. Greenwich, CT: New York Graphic Society.

———. 1973b. *Image of the People*. Greenwich, CT: New York Graphic Society.

———. 1974. "The conditions of artistic creation." *Times Literary Supplement* (May 24): 551–562.

Colangelo, N., D. Dustin, and C. Foxley. 1985. *Multicultural Nonsexist Education: A Human Relations Approach*. 2nd ed. Dubuque, IA: Kendall/Hunt.

Collins, H. T. 1991. *Global Primer: Skills for a Changing World*. Denver, CO: University of Denver Press.

Corrin, L., ed. (in press). *Fred Wilson's "Mining the Museum": Interrogating the Institution*. New York: New Press.

Danto, A. C. 1990. *Encounters and Reflections: Art in the Historical Present*. New York: Farrar, Straus & Giroux.

Derman-Sparks, L. 1989. *Anti-Bias Curriculum: Tools for Empowering Children*. Washington, DC: National Association for the Education of Young Children.

Dissanayake, E. 1988. *What Is Art For?* Seattle: University of Washington Press.

———. 1992. *Homo aestheticus: Where Art Comes From and Why*. New York: Free Press.

Dobbs, S. M. 1989. "Discipline-based Art Education: Some questions and answers." *NASSP Bulletin* 73 (May): 7–13.

———. 1992. *The DBAE Handbook: An Overview of Discipline-based Art Education.* Santa Monica, CA: Getty Center for Education in the Arts.

Dumenco, S. (1992). "Lost and found: Artist Fred Wilson pulls apart Maryland's hidden past." *City Paper* (May 1–7): 9–12.

Eaton, M. M. 1983. *Art and Non-Art: Reflections on a Orange Crate and a Moosecall.* Cranbury, NJ: Fairleigh-Dickenson University Press.

———. 1988. *Basic Issues in Aesthetics.* Belmont, CA: Wadsworth Publishing Co.

———. 1989. *Aesthetics and the Good Life.* Cranbury, NJ: Fairleigh-Dickenson University Press.

Freeman, R. E., ed. 1986. *Promising Practices in Global Education: A Handbook with Case Studies.* New York: National Council on Foreign Language and International Studies.

Gates, H. L., Jr., ed. 1986. *"Race," Writing, and Difference.* Chicago: University of Chicago Press.

Gomez-Peña, G. 1991. "On nationalism." *Art in America* (September): 126–127, 160.

Grant, C. A. and C. E. Sleeter. 1986. *After the School Bell Rings.* Philadelphia: Falmer Press.

———. 1992. *Research and Multicultural Education: From the Margins to the Mainstream.* Philadelphia: Falmer Press.

Hernandez, H. 1989. *Multicultural Education: A Teacher's Guide to Content and Process.* New York: Macmillan.

Hurwitz, A. and M. Day. 1991. *Children and their Art: Methods for the Elementary School.* 5th ed. New York: Harcourt Brace Jovanovich.

Joint Center for Political Studies. 1989. *Visions of a Better Way: A Black Appraisal of Public Schooling.* Washington, DC: Joint Center for Political Studies Press.

Kahn, D. and D. Neumaier, eds. 1985. *Cultures in Contention.* Seattle, WA: Real Comet Press.

Karp, I., C. M. Kreamer, and S. D. Lavine, eds. 1992. *Museums and Communities: Debating Public Culture.* Washington, DC: Smithsonian Institution Press.

Karp, I. and S. D. Lavine, eds. 1990. *Exhibiting Cultures: The Poetics and Politics of Museum Display.* Washington, DC: Smithsonian Institution Press.

Kerr, B. A. 1985. *Smart Girls, Gifted Women.* Dayton: Ohio Psychology Press.

Krause, T. 1983. *Multicultural Mathematics Materials.* Reston, VA: National Council of Mathematics Teachers.

Lanier, V. 1969. "The teaching of art as social revolution." *Phi Delta Kappan* 50 (6): 314–319.

Lippard, L. 1983. *Overlay: Contemporary Art and the Art of Prehistory.* New York: Pantheon Books.

———. 1990. *Mixed Blessings: New Art in a Multicultural America.* New York: Pantheon Books.

Lynch, J. 1990. *Multicultural Curriculum.* London: Trafalger Square.

Mason, R. 1988. *Art Education and Multiculturalism.* London: Croom Helm.

McFee, J. K. (1970). *Preparation for Art* (2nd edition). Belmont, CA: Wadsworth.

———. 1988. "Cultural dimensions in the teaching of art," in F. M. Farley and R. W. Neperud eds. *The Foundations of Aesthetics, Art, and Art Education.* New York: Praeger.

——— and R. Degge. (1977). *Art, Culture, and Environment.* Belmont, CA: Wadsworth.

Messenger, P.M., ed. 1989. *The Ethics of Collecting Cultural Property: Whose Culture? Whose Property?* Albuquerque: University of New Mexico Press.

Modgil, S., G. Verma, M. Kanka, and C. Modgil, eds. 1986. *Multicultural Education: The Interminable Debate.* Philadelphia, PA: Taylor & Francis.

National Commission on Excellence in Education. 1983. *A Nation at Risk: The Imperative for Educational Reform.* Washington, DC: Government Printing Office.

Nochlin, L. 1971. "Why have there been no great women artists?" pp. 480–510 in V. Gornick and B. Moran, eds. *Women in Sexist Society: Studies in Power and Powerlessness.* New York: Basic Books.

Orfield, G. 1992. *Turning Back the Clock: The Reagan-Bush Retreat from Civil Rights in Higher Education.* Lanham, MD: University Press of America.

Preziosi, D. 1989. *Rethinking Art History: Meditations on a Coy Science.* New Haven, CT: Yale University Press.

Price, S. 1989. *Primitive Art in Civilized Places.* Chicago: University of Chicago Press.

Rosen, R. and C. Brawer, eds. 1989. *Making Their Mark: Women Artists Move into the Mainstream, 1970–85.* New York: Abbeville Press.

Sims, W. E. and B. Bass de Martinez. 1981. *Perspectives in Multicultural Education.* Lanham, MD: University Press of America.

Simonson, R. and S. Walker. 1988. *The Graywolf Annual Five: Multicultural Literacy.* St. Paul, MN: Graywolf Press.

Sleeter, C. E., ed. 1991. *Empowerment Through Multicultural Education.* Albany: SUNY Press.

Sleeter, C. E. and C. A. Grant. 1988. *Making Choices for Multicultural Education: Some Approaches to Race, Class, and Gender.* Columbus, OH: Charles E. Merrill.

Steele, S. 1990. *The Content of Our Character: A New Vision of Race in America.* New York: St. Martin's Press.

Storr, R. 1991. *Devil on the Stairs: Looking Back on the Eighties.* Philadelphia: Institute of Contemporary Art, University of Pennsylvania.

Tiedt, P. L. and I. M. Tiedt. 1989. *Multicultural Teaching: A Handbook of Activities, Information, and Resources.* 3rd ed. Boston: Allyn & Bacon.

Torgovnick, M. 1990. *Gone Primitive.* Chicago, IL: University of Chicago Press.

Young, B. 1990. *Art, Culture, and Ethnicity.* Reston, VA: National Art Education Association.

RESOURCES

The following books, games, videotapes, and other materials were available in the resource room at *DBAE and Cultural Diversity*. The list is not meant to be comprehensive and inclusion does not imply endorsement by the Getty Center for Education in the Arts.

CHILDREN'S BOOKS AND GAMES

Alaro. Oxfam.
Through matching and observation, children can get to know a specific form of artistic expression in this activity pack based on traditional textile production in Nigeria.

The Apaches and Navajos. Crizmac.
This easy-to-read picture book is used to introduce K–4 students to these Native American Cultures.

Artery. Crizmac.
This art game is designed to develop students' skills of description, analysis, and interpretation; to identify subject matter; and to recognize properties of artworks. Includes 54 5 x 8" art reproductions of western and non-western images. Playing cards are in English and Spanish.

Bellerophon Coloring Books:
Ancient China
The Ancient Near East
Ancient Africa
Ancient Egypt
Ancient Hawaii
Ancient India
Ancient Ireland
Great Indians of California
Incas, Aztecs and Mayas
Japan
Queen Nefertiti
The Story of Africa and Her Flags to Color

Board Games from Around the World. Oxfam.
Three different board games are included in this pack for middle elementary students.

Civil War Heroines. Bellerophon Books.
These daring women and their heroic stories are presented.

Cowgirls. Bellerophon Books.
Shows working ranch women, movie queens, rodeo stars, and Wild Horse Annie, who worked to save wild mustangs.

Georgia O'Keeffe. Crizmac.
Eight pages of full-color reproductions are included in the easy-to-read biography of this American painter.

Great Indian Chiefs. Bellerophon Books.
Fifty stories of Indian chiefs are told.

Great Women Paper Dolls. Bellerophon Books.
This paper doll book includes Joan of Arc, Susan B. Anthony, and Golda Meir.

Handbook of American Indian Games. Music for Little People.
More than 150 games are introduced in this book. The authors explain the games' origins, how they were played, and the role games played in tribal life.

Infamous Women. Bellerophon Books.
Messalina, Agrippina, Lucrezia Borgia, and Empress Wu are among those included in this paper doll book.

The Iroquois. Crizmac.
A picture book for grades K–4.

Manomiya. Oxfam.
This game, designed for ages 16 and above, is based on African case studies. It shows how a new development scheme undermined local women's role as food producers.

"Multicultural Celebrations." Modern Curriculum Press.
Created in conjunction with The Children's Museum, Boston.
Dara's Cambodian New Year.
Who Am I?

Chinese New Year's Dragon
Carnival
Imani's Gift at Kwanza
Tet: The New Year
Powwow
Strawberry Thanksgiving
A First Passover
Korean Children's Day
Three Kings' Day
Fiesta!

Myths and Legends of the Haida, Indians of the Northwest. Bellerophon Books.
Tales of Raven, Eagles, Bear Mother, etc.

Myths and Legends of the Indians of the Southwest I and II. Bellerophon Books.
Book I includes Navajo, Pima, and Apache stories. Book II includes tales from the Hopi, Acoma, Tewa, and Zuni peoples.

Native Americans. Aladdin Books.
A set of six books about Native American children. The teacher's enrichment guide provides ideas for activities in various subject areas.
Hawk, I'm Your Brother
The Girl Who Loved Horses
Buffalo Woman
The Gift of the Sacred Dog
When Clay Sings
The Desert Is Theirs

The Seminoles. Crizmac.
This easy to read picture book for grades K–4 introduces students to this Native American culture.

Shoshoni. Crizmac.
This picture book can be used as a resource to introduce students to the Shoshone culture.

The Sioux. Crizmac.
This picture book is suggested for grades K–4.

Spiderwoman's Dream. Crizmac.
Indian legends are interpreted in poetry and art.

The Story of Mexico. Bellerophon Books.
Mexican heroes and heroines and their stories are presented.

Tar Beach. Crown Publishers.
A picture book, based on her story quilt, by artist Faith Ringgold.

Token Response. Crizmac.
This game challenges students to ask questions and make distinctions about art. Eight sets of paper tokens, reproducible activity forms in English and Spanish, and teacher's guide are included. For 3 to 30 players, grades K–adult.

Totem Poles. Bellerophon Books.
Parts that assemble a ceiling-high totem pole are in this book.

Women Composers. Bellerophon Books.
Stories of well-known and obscure women from the middle ages to today.

The Young Reader. Boston Globe. Volume VI, No. 2, Spring 1992.
This issue of The Young Reader gives the titles and abstracts of the Boston Globe's Top 25 books in multicultural reading for children.

CURRICULAR MATERIALS

Accepting Diversity: A Multicultural Art Approach. Barbara Fehrs-Rampolla.
This guide from Holmdale High School in New Jersey offers educators a curriculum for developing their students' self-esteem and increasing their understanding of a multicultural society. Through art, high school students are introduced to the similarities that exist among diverse cultures.

Access: Information on Global, International, and Foreign Language Education. American Forum for Global Education.
This newsletter, which is produced eight times a year, contains articles, resource information, employment opportunities and program announcements about issues relating to multicultural education.

African-American History: Heroism, Struggle, and Hope. Society for Visual Education.
A curriculum that documents the contributions of African-Americans to the growth of the United States. Includes audio tapes, filmstrips, and teacher's guide.

America's Civil Rights Movement. Teaching Tolerance.
A video, publication and lesson plans using creative and critical thinking are included in this teaching package.

Ancient Civilizations. Zephyr.
This packet allows students in grades K–8 to travel back in time to ancient Middle Eastern civilizations.

Anti-Racism and Art in Britain and South Africa. Oxfam.
A teaching program for secondary teaching that includes a poster, five slides, a set of photos and background notes.

Architexture: A Shelter Word. Zephyr.
A source guide for self-directed study of the architecture of various world cultures.

Art Against Apartheid. Oxfam.
This pack enables teachers to examine issues relating to apartheid and racism in South Africa and the United Kingdom through an active learning and art-based approach. Poster and set of photos included.

Art from Many Hands: Multicultural Art Projects. Zephyr.
Step-by-step instructions for thirty-seven art projects are included in this handbook for grades 3 and up.

Asian American Books. Japanese American Curriculum Project.
A catalogue of elementary, secondary, and reference books available from the JACP, whose mission is to develop and disseminate Asian American educational materials.

Aspects of Africa: Questioning Our Perceptions. Oxfam.
Twenty color slides are presented to help challenge the image of Africa and Africans.

Behind the Scenes. Oxfam.
This inservice pack with photos and activities examines issues of justice and equality within primary schools.

Beyond Blue Mountains: A Traveling Collection of Contemporary Native American Artworks. Washington State Arts Commission.
This workbook encourages critical thinking and the analysis of ideas through the examination of the art of a variety of cultures in contemporary United States.

Beyond the Frame: Young People and Photography. Oxfam.
Photos help form the way we see the world: this magazine looks at the way they are used and includes activity suggestions.

Bilingual Education Handbook: Designing Instruction for LEP Students. California Department of Education.
This guidebook is meant as an aid and model bilingual program for teachers working directly with language-minority students.

California Perspectives. California Tomorrow.
An anthology of readings about culture and curricula from the California Tomorrow Education for a Diverse Society project.

The Columbus Encounter: A Multicultural View. Zephyr.
Takes a multicultural look at Columbus's voyages to the Americas. Self-directed study units for grades K–3 and 4–8.

Committed to Print: Social and Political Themes in Recent American Printed Art. Sandak.
These 88 slides are based on the exhibition held at the Museum of Modern Art, New York, in 1988.

Comparing Cultures. Zephyr.
By integrating social studies and language arts, these units use letters, and personal accounts to explore other cultures. Spiral-bound, grades 4–9.

Cultural Conflicts: Case Studies in a World of Change. Zephyr.
This book presents a series of cultural change situations around the world. Grades 5–12.

Cultural Journey: Eighty-four Art and Social Studies Activities Around the World. Zephyr.
This softbound book introduces the study of cultural anthropology integrating science, geography and art. Grades 7–12.

Creactivity. Oxfam.
This manual includes five workshops for youth groups on learning about other cultures, people's rights, natural environment, power and oppression, and cooperation.

The Decade Show: Framework of Identity in the 1980s. Sandak.
These slides are from the New Museum of Contemporary Hispanic Art, the New Museum of Contemporary Art, and the Studio Museum of Harlem.
Part I: Visual Art—106 slides.
Part II: Video and Performance Art—43 slides.

Economics for Change: Understanding Economic Inequality from Different Viewpoints. Oxfam.
This unit is part of a curriculum project about economics and development education that helps young people increase their understanding of economic argument and the economic division of inequality. For use by student 14 years old and up.

Embracing Diversity: Teachers' Voices from California's Classrooms. California Tomorrow.
Reports the results of a project that documented the needs and experiences of foreign-born children in California schools, and to examine the challenges immigration poses to the public school system.

End of the Innocence. Anti-Defamation League of B'nai B'rith.
A course study of the Holocaust that uses the diary of Anne Frank as a central focus.

Ethnic Perspectives Series. REACH Center.
This set of four books presents U.S. history from diverse ethnic points of view. The set includes the following titles:
The Asian American Experience
An African American Perspective
An American Indian Perspective
An Hispanic/Latino Perspective

Everything Is Somewhere: The Geography Quiz Book. Zephyr.
This serious yet humorous look at geography contains 30 quizzes on countries, climate, food and health. Grades 5 and up.

Exploring the Third World: Development in Africa, Asia, and Latin America. American Forum for Global Education.
This curriculum unit focuses on issues of development in the Third World. Lessons focus on economy, environment, and population. For grades 7–12 to adult.

Festivals of Light. U.S. Committee for UNICEF.
A multimedia kit designed to introduce audiences to similarities and differences in the ways festivals of light are celebrated around the world and to stimulate interest in the lives and cultures of the people portrayed.

Folktales: Teaching Reading through Visualization and Drawing. Zephyr.
Promotes reading and comprehension through the presentation of multicultural stories and drawing activities.

Fun with Hieroglyphics. Zephyr.
Set of twenty-four stamps representing the sounds in the hieroglyphics alphabet, an ink pad and explanatory booklet are included in this kit.

Get the Picture. Oxfam.
This teacher's handbook explores ideas about visual literacy in the primary classroom. Included are strategies for investigating the "truth" of photographs in their representation of reality, and issues of gender and race are raised.

Getting on with Others. Oxfam.
An activity pack for 6–9 year-olds offers 16 sessions on group work and cooperation. This pack contains photos and world map.

Global Art Slide Set. Sandak.
This slide set is organized by culture and includes Africa, Middle East, India, China, Japan, and Latin America.

Global Connections Report. Oxfam.
This is a review of secondary school links between Britain and countries in developing nations.

Global Primer. Center for Teaching International Relations.
Grades K–8. This book offers a variety of skills-oriented learning activities designed for the multidisciplinary elements classroom. Comb-bound, with reproducible student handouts.

Hidden Messages. Oxfam.
This book includes pictures, stories, and printed material for primary school children and suggests activities which examines the question of bias in language.

Hispanic Folk Songs of the Southwest. Center for Teaching International Relations.
An overview of the Hispanic people of the Southwest. A cassette tape is included.

Images. Oxfam.
Photographs and activity cards examine the way 9–13 year-olds see the world. The activities address gender roles, racism, wealth and poverty.

Images of Africa: The UK Report. Oxfam.
The UK report is part of an international study of images of the 1984–85 famine in Ethiopia and other African countries.

Immigration: Identifying Propaganda Techniques. Greenhaven Press.
Suitable for the elementary curriculum, this book raises such issues as the problems of illegal immigration and bilingual education.

In Search of Mutual Understanding: A Classroom Approach to Japan. Center for Teaching International Relations.
Grades 7–12. Offers a variety of lessons, exercises and activities designed to help teachers provide accurate information about Japan. Focusses on major human activities such as religion, language and education.

Interact: Learning through Involvement. Interact.
These teaching packets present scenarios in which students confront issues of cultural diversity through the simulation of roles. Titles of simulations:
Amigos: a race through Latin America
Empathy: the experience of the physically handicapped
Equality: the struggle for racial equality in a typical American city
Gateway: immigration issues in past and present America
Herstory: male and female roles
Honor: coming of age in Native America before the horse

Investigating Images: Working with Pictures on an International Theme. Oxfam.
Using the theme of buying and selling, the activities develop skills of visual analysis and observation. Includes 20 color slides and photographs.

The Jade Garden: Ancient to Modern China. Zephyr.
Grades K–8. This learning packet assists students in the study of China.

Kei Road Evictions. Oxfam.
This activity pack, based on a real incident, is designed to promote understanding of the legal, economic and social problems of rural workers in South Africa.

Making a World of Difference: Creative Activities for Global Learning. Center for Teaching International Relations.
This handbook offers exercises for strengthening a global perspective and emphasizes the arts.

Mexico as Seen by Her Children. National Foundation for the Improvement of Education.
An instructional kit of materials about childhood in Mexico.

Model Curriculum for Human Rights and Genocide. California State Board of Education.
Serves as a guide for classroom teachers on the inclusion of studies on human rights and genocide in the curriculum.

Multicultural Art. Sandak.
These 90 slides introduce the art and culture of many non-European cultures.

Multicultural Read-Aloud Kit. REACH Center.
Elementary school level. A guide to selected multicultural books complete with notations to the teacher, discussion questions, and follow-up activities for use during storytime.

Myself and Others. American Forum for Global Education.
Themes treated in this resource include interconnections between people, cooperation, and communication. Twenty-five lesson plans for grades K–5.

Northwest Coast Basketry Models. Kunstdame.
These baskets are of the Tlingit, Klickitat, Clallam, and Lillooet people. These models are embossed, die-cut, and ready for assembly by children or adults. Models range from 30" to 4 ½' tall and include descriptive essays.

One World. Oxfam.
This report describes a national residential weekend for young people held in 1986. It also offers a model for others wishing to organize similar events.

Patriotism: Recognizing Stereotypes. Greenhaven Press.
Three debates discuss the merits of patriotism. Stereotypes are identified.

Picturing People: Challenging Stereotypes. Oxfam.
Using the theme of youth, this unit looks at the role of the media in forming stereotypes.

Profiles on Prejudice. Oxfam.
This handbook introduces the issues underlying prejudice and includes simulation and role-playing exercises.

Project REACH Teacher Guide and Training Manual. REACH Center.
Middle/junior high school. Provides lessons and activities to prepare students to live effectively and positively in a culturally diverse world.

Project 10 Handbook: Addressing Lesbian and Gay Issues in Our Schools. Project 10.
A resource directory for teachers, guidance counselors, parents and school-based adolescent care providers.

Racism in America. Greenhaven Press.
This book is part of the Opposing Viewpoints series, developed to help students become discriminating consumers of information.

REACH for Kids Seed Curriculum. REACH Center.
Grades K–6. Provides a model for integrating the disciplines and infusing lessons and activities with multicultural/global perspectives.

Rebel Music. Oxfam.
The music of Jamaica and its influence in the United Kingdom is presented in this magazine for high school students.

Reflections on Women: Exploring Leadership through the Study of Five Great Lives. Zephyr.
Catherine the Great, Queen Victoria, Indira Gandhi, Eleanor Roosevelt, and Golda Meir are included in this unit, which contains task cards and discussion questions.

A Salute to Historic Black Women. National Women's History Project.
This booklet recognizes 24 African-American women who were pioneers in the struggle for advancement in society. One page biographies, crossword puzzle and quizzes are also included.

See Me, Share My World: Understanding the Third World Through Children's Art. Zephyr.
Children can learn about other children through the drawings of youngsters from six Third World countries. Teaching guide, student activity pages, 16 study prints, and a training video.

Some Crafty Things to Do. Oxfam.
This handbook of things for young people to make and do includes recipes and games from developing nations.

Southwest Pueblo Pottery Models. Kunstdame.
These ready-to-assemble models are of San Ildefonso, Zia, Jemez, and Acoma pottery. The pottery is reproduced in black, adobe tan, and terra-cotta red on card stock. The models stand 3¾" tall and include descriptive essays.

SPARCplug. Social and Public Art Resource Center.
This publication features public art, news, opinions and reports.

Teacher, They Called Me a _____! Anti-Defamation League of B'nai B'rith.
Reports the results of a study of prejudice among elementary students and suggests methods of combatting various forms of discrimination in the classroom.

Teaching About Conflict: Northern Ireland. Center for Teaching International Relations.
Grades 6–12. This unit gives an overview of the past and recent history of Northern Ireland and demonstrates the similarities between this conflict and others such as the Israeli-Arab conflict.

Teaching About Cultural Awareness. Center for Teaching International Relations.
This handbook looks at the diversity of ideas and cultures in the context of further developing Spanish-language skills. Handouts are written in Spanish. Grades 4–12.

Teaching About Ethnic Heritage. Center for Teaching International Relations.
This book is designed to aid students in linking their ethnicity, identity and heritage. Includes bibliographies on ethnic heritage and genealogy.

Teaching Tolerance **Magazine.** Teaching Tolerance.
Teaching Tolerance is a biannual publication that offers a collection of ready-to-use ideas and strategies in all subject areas.

Through African Eyes. American Forum for Global Education.
This textbook helps students understand other societies through the eyes of other people. Readings cover traditional, colonial, and modern-day Africa.

Through Asian Eyes. American Forum for Global Education.
Materials examine and seek to help students understand Asian values. Textbook series include:
Through Indian Eyes: The Living Tradition
Through Chinese Eyes: Revolution and Transformation
Through Japanese Eyes.

Through Middle Eastern Eyes. American Forum for Global Education.
This textbook introduces fundamental values or conflicts which have historical roots and are affecting change in the contemporary Middle East.

Using Conflict Creatively. Oxfam.
This youth magazine offers ideas and activities for exploring conflict and suggests ways of dealing with it constructively.

Understanding You and Them: Tips for Teaching About Ethnicity. ERIC Clearinghouse for Social Studies/Social Science Education.
Presents a comprehensive view of how ethnicity should be treated in the curriculum and the types of resources and materials available for studies of cultural diversity.

Women in the Military: Current Controversies. Greenhaven Press.
Raises questions about the issue of women in the military and presents the opinions of a wide spectrum of experts and laypersons.

Zuni: Traditions in Clay. Crizmac.
This unit introduces traditional techniques of Native American pottery. Includes a 22 x 28" reproduction of a Zuni water jar, twelve slides, a summary, and studio and language arts activities.

MATERIALS FROM MUSEUMS

African Art. Cleveland Museum of Art.
This slide packet contains twenty slides and a brief description of each.

African Art. Minneapolis Institute of Arts.
Set of slides and written information about the art from several geographical areas of Africa.

Ancient Art of the American Woodland Indians. Minneapolis Institute of Arts.
A set of slides from the Index of American Design at the National Gallery of Art in Washington, D.C.; the slides are accompanied by an explanatory pamphlet that describes each image.

Approaches for Looking at Art. J. B. Speed Art Museum.
With a look beyond American and European artworks, the cultural context and art from three areas of the world are presented. Includes slides, question guide and resource sheet.

Art and Life in Africa. Minneapolis Institute of Arts.
Uses works of art from the collection of the Minneapolis Institute of Arts to introduce students to the diversity of art made by various western and central African peoples.

The Arts of Japan. Los Angles County Museum of Art.
This packet includes 6 slides with descriptions, an outline of classroom discussion points and activities.

Asian Art for Young People: Curriculum Guide, K–12. Asian Art Museum of San Francisco.
This curricular guide of references, stories and activities was developed to accompany a series of 7 art posters from the Museum.

Caribbean Festival Arts. Minneapolis Institute of Arts.
Focuses on three festival traditions from the West Indies. The resource kit is designed to assist teachers in exploring the Caribbean community with students.

The Child: Concepts of Self. J. B. Speed Art Museum.
This kit focusses on aspects of the development of a child's self-concept by using selected artworks. Includes slides, question guide and resource sheet.

Chinese Art. Cleveland Museum of Art.
Twenty slides and a brief guide of Chinese art are presented.

Chinese Art Treasures. Cleveland Museum of Art.
Most of the art presented in the 20 slides in this packet enriched the tombs constructed for the aristocracy prior to the eighth century. A script is included.

Chinese Ceramics. Museum of Fine Arts, Boston.
This slide set is available in a set of 20 or 40.

The Chinese Past: 6,000 Years of Art and Culture.
Minneapolis Institute of Arts.
Color slide program provides information about the works of art from "The Exhibition of Archaeological Finds of the People's Republic of China" held at the National Gallery of Art, Washington, D.C.

A Cleveland Bestiary. Cleveland Museum of Art.
Animals from medieval Europe and a variety of cultures and historical periods are depicted in these 20 slides. Includes suggestions for student activities.

"Degenerate Art": The Fate of the Avant-Garde in Nazi Germany. Los Angeles County Museum of Art.
This packet is based on the exhibition that partially recreated the exhibition staged by the Nazis in 1937 to ridicule modern art. Six slides with descriptions, information and suggestions for classroom discussion are included.

Egyptian Art. Cleveland Museum of Art.
An introduction to the art of Egypt, a booklet, 20 slides and activity sheets are included in this packet.

The Far North: 2,000 Years of American Eskimo and Indian Art. Minneapolis Institute of Arts.
Based on an exhibition held at the National Gallery of Art, Washington, D.C., that brought together works of art produced by the native peoples of Alaska. Provides information about the art objects and fosters an awareness of indigenous cultures.

The Floating World: Japanese Paintings and Prints.
Cleveland Museum of Art.
This packet contains 20 slides with an explanation and introduction to Japanese art.

Folk Arts of the Spanish Southwest. Minneapolis Institute of Arts.
A set of slides from the Index of American Design at the National Gallery of Art in Washington, D.C.; the slides are accompanied by an explanatory pamphlet that describes each image.

From Victory to Freedom: The African American Experience. National Afro-American Museum and Cultural Center.
Illuminates the role that African Americans have played in the formation of the national identity of the United States.

Han Tomb Tiles. Museum of Fine Arts, Boston.
Twelve slides are of a lintel and pediment from a tomb of the Han period.

Henry Ossawa Tanner. Philadelphia Museum of Art.
This packet contains 10 slides, script and activities, a biography, map, time line, and video.

Human Conflict. J. B. Speed Art Museum.
The artworks in these slides show images associated with various types of conflict, including angry, physical confrontations; problems caused by poor communication skills, struggle with emotions and the making of difficult personal decisions. Slides, question guide and resource sheet are included.

Illustrations and Illumination: Indian Miniature Paintings. Asian Art Museum of San Francisco.
Lessons in conquest and art, tales and legends from Asia and the Pacific, a bibliography, and 20 slides are presented.

Indian and Southeast Asian Art. Los Angeles County Museum of Art.
This packet is intended to help children between the ages of eight and twelve learn about works of art on their own. It includes an essay on Indian miniature painting and 3 reproductions (10 × 14").

Indian Asia. Cleveland Museum of Art.
Twenty slides and an introduction are presented.

The Islamic World and the Art of Persia. Asian Art Museum of San Francisco.
Twenty slides, description, and information are presented.

Japanese Art. Cleveland Museum of Art.
This unit includes an introduction to the art of Japan, 20 slides, and a curriculum connections list.

Korean Ceramics: Vessels of a Culture. Asian Art Museum of San Francisco.
Classroom activities, glossary, a bibliography, map, 20 slides, and information are included.

Mathematics of Islamic Art. Minneapolis Institute of Arts. 1978.
Set of slides and written information that may be adapted to various grade levels.

The Middle East: Splendors Past and Present. Asian Art Museum of San Francisco.
Twenty slides of art and their descriptions, as well as 20 slides of the political and physical geography of the Middle East are presented.

Multicultural Bingo. Museum of Fine Arts, Boston.
Activity focussed kit with instructions, supplies, objects, books and pictures.

Multicultural Hopscotch. Museum of Fine Arts, Boston.
A game, available for rental from the museum, that addresses issues of cultural diversity and art.

The Mythic Impulse: Gods and Animals in Indian Art. Asian Art Museum of San Francisco.
This collection of twenty slides introduces some of the many forms of the deity worshipped in India. Stories of the gods are included.

Narrative Art of India and Southeast Asia. Asian Art Museum of San Francisco.
This packet introduces some of the ways in which the people of India and Southeast Asia have regarded and worshipped their gods. Twenty slides and classroom projects are included.

Nineteenth and Twentieth Century Japanese Batiks. Museum of Fine Arts, Boston.
Thirty-nine slides are included in this set.

Out of the East Horizon. Seattle Art Museum.
This teacher resource packet examines some of the arts associated with traditional Chinese scholarship. Includes lessons, handouts, sixteen slides, and a Chinese music cassette tape.

Persian Manuscripts from Mesopotamia. Museum of Fine Arts, Boston.
This slide set contains 25 slides.

Plains Indian Painting. Joslyn Art Museum.
This resource packet introduces students to Plains Indian painting. Slides and explanatory notes are included.

The Powers of the Feminine: Sacred Images of India and Southeast Asia. Asian Art Museum of San Francisco.
Twenty slides and their descriptions, a sheet of symbols and their meanings, maps, and classroom activities are in this packet.

Pre-Columbian Art. Cleveland Museum of Art.
Twenty slides with an explanation on each are presented.

Pre-Columbian Art. Saint Louis Art Museum.
A kit of twenty slides from 18 cultures, a 22-minute audio cassette and a teacher's guide.

Quest for Eternity: Chinese Ceramic Funerary Sculptures. Los Angeles County Museum of Art.
Six slides with descriptions, a list of resources for curricular development in Chinese studies, and suggestions for classroom activities are included in this packet.

The Romance of the Taj Mahal. Los Angeles County Museum of Art.
This packet contains 6 slides with descriptions, a chronology, classroom activities and a 13-minute video of India.

Saint Louis Art Museum Handbook of Lesson Plans II. Saint Louis Art Museum.
This handbook contains 40 lessons that integrate the Museum's art collection with areas of the curriculum.

Screens, Noh and Tea—Japanese Style. Cleveland Museum of Art.
This packet contains 20 slides with explanation and a curriculum connections sheet.

Shared Treasures: Gifts from Our Ancestors. Seattle Art Museum.
The resource unit presents the art and culture of the Northwest Coast Native community. Lessons, activities and a set of 20 slides, and descriptive script are included.

Small World. Saint Louis Art Museum.
Part One, Children in the Museum, is a guide to works of art in the Museum that show children from around the world. Part Two, Animal Hunt, focuses on global art that depicts animals. Each section includes color prints, activities and information packets.

Spain and Latin America: A Linked Tradition. Saint Louis Art Museum.
This kit of 20 slides offers a brief overview of Spanish art and its connections with the art of Latin America. Teaching suggestions are included.

Spring Blossoms, Autumn Moon: Japanese Art for the Classroom. Seattle Art Museum.
This multidisciplinary unit is designed to show how nature is recognized and honored through art in Japanese culture. Twenty slides and a tape of Japanese stories, vocabulary, poetry, and music are included.

Surrounded by Beauty: The Arts of Native America. Minneapolis Institute of Arts.
Introduces students to a sampling of Native American art at The Minneapolis Institute of the Arts. Each object is discussed in terms of the cultural context in which it was created.

Tartars Traveling on Horseback. Museum of Fine Arts, Boston.
All 33 slides in this set are of one hand scroll of China from the late tenth century.

Ukiyo-e: Japanese Woodblock Prints. Museum of Fine Arts, Boston.
This slide set includes 32 slides.

Views of a Vanishing Frontier: Bodmer-Maximillian Expedition 1832–34. Joslyn Art Museum.
This Outreach Trunk contains objects, slides, videotapes, and other interpretive materials.

What If You Couldn't? Children's Museum, Boston.
A multimedia curriculum kit that addresses issues of disabilities. Includes activity suggestions and supplies, models, artifacts and audiovisual materials. Available for rental.

MUSIC

All tapes from Music for Little People.

African Songs and Rhythms for Children.
This tape emphasizes the close interrelationship between the traditional African approach and Orff Schulwerk rhythm movement.

Africa: The Machete Ensemble.
Performances of Afro-Cuban jazz and Afro-Latin traditions.

Beyond Boundaries.
Music from West Africa, the Middle East, Europe, Brazil, Cuba, and California.

Earthbeat: Beyond Boundaries.
The music of a dozen cultures is explored in this tape.

Jazayer.
Middle Eastern classical compositions for contemplation.

Obo Addy.
A celebration of the musical traditions of Ghana, West Africa.

Okropong: Traditional Music of Ghana.
Obo Addy, a master drummer of the Ga people, celebrates the music of West Africa.

POSTERS, PRINTS, AND REPRODUCTIONS

Art First Nations: Tradition and Innovation. Art Image, Inc.
Each kit contains a teacher's guide and 20 laminated art prints. The program highlights the artistic innovations and traditions in five geographical and cultural areas.

Celebrate Black Women's History. National Women's History Project.
Nine African-American women, including Lena Horne, Lorraine Hansberry, and Harriet Tubman, are represented on this poster.

Great Black Americans Posters Series 1 and 2.
Knowledge Unlimited.
Each poster series features Black Americans. Accompanying text on each poster (17 × 22") describes the life and achievements of the person featured. Includes a teacher's guide.

Great American Women Poster Set. Knowledge Unlimited.
This series of posters (17 × 22") highlights ten outstanding American women and their achievements, features original art and has accompanying text on each poster. A booklet includes more biographical information, activities and a biography.

Hispanic Heritage Poster Series. Knowledge Unlimited.
This poster set portrays some of the most prominent and influential Hispanics through history to the present. The text describes the life and achievements of the person featured, and the teacher's guide has additional background information and activities.

Images. Oxfam.
"A photograph is usually looked at, seldom looked into." This quote by Ansel Adams is used in this black and white poster.

Mask Prints. Crystal Productions.
This portfolio of twelve prints (16 × 12") depicts a wide variety of masks from ancient to contemporary times, and from all regions of the world.

The Math of Africa. Knowledge Unlimited.
This poster (23 × 35") features the Ashanti weights and measures, board games, and finger gestures representing numbers.

The Math of Japan. Knowledge Unlimited.
This 23 × 35" poster explains Japanese counting systems.

Multicultural Art Print Series. Getty Center for Education in the Arts, distributed by Crystal Productions.
Two series of two sets of posters: MAPS I, African-American Art and Pacific Asian Art. MAPS II, American Indian and Mexican-American Art.

Multicultural Art Series. Shorewood Fine Arts Reproductions.
Imagery from African, Egyptian, American-Indian, Mexican, Puerto-Rican, Chinese, ancient Persian, and ancient European sources.

Native American Reproductions. Crizmac.
This edition of 18 × 22" lithographs highlights the artworks of six societies. Each reproduction has a teacher's supplement to help present information. Grades 3–12.

Salute to Historic Black Women. National Women's History Project.
This poster illustrates eighteen women including Rannie Helen Burroughs, Mary Ann Shadd Cary, Mary Ellen Pleasant, Maggie Lena Walker, and Harriet Ross Tubman.

Weaving the Stories of Our Lives. National Women's Project.
Poster developed to celebrate National Women's History Week, March 6–12. The poster features Laura Someral, basketmaker.

Whose World Is the World? Oxfam.
A set of 12 posters forms the basis for teaching about racism within the context of the world-wide development of Western economic power over the past 400 years.

Women's History Month. National Women's History Project.
This miniposter announces the congressional resolution that designates the week of March 12th as "Women's History Week."

VIDEOCASSETTES AND FILMSTRIPS

African American Art: Past and Present. Reading & O'Reilly.
This comprehensive survey of African American art consists of three 30-minute VHS tapes and guides.

Bridging the Culture Gap. Copeland Griggs Productions.
This video contrasts one's own unconscious cultural values with those of diverse world cultures and reveals the importance of cross-cultural understanding. 30 minutes.

Champions of Diversity. Copeland Griggs Productions.
Documents how change occurs within people; emphasizes personal growth, changing demographics and the benefits of diversity. 30 minutes.

Chinese Art and Architecture. Alarion Press.
This program traces the neolithic design of animal spirits through present day art. Three programs on two videos, or 3 filmstrips, cassettes, teaching manual and poster are included in this unit for grades 4–9.

Communicating Across Cultures. Copeland Griggs Productions.
Shows how misunderstandings result from different styles of communication and addresses the discomfort often felt by people when dealing with issues of races and gender. 30 minutes.

DBAE Instructional Videos. Great Plains National Instructional Television Library.
These videos were produced in conjunction with Prairie Visions, on of the six regional DBAE programs funded by the Getty Center for Education in the Arts. The titles are:
Expanding Vision in Art Education: Models in DBAE
Discipline-based Art Education I
Discipline-based Art Education II

Gente del Sol. Crizmac.

This is a series of comprehensive art units that introduces students to three Native cultures of the Americas. The art forms featured are: Mexican bark painting, Guatemalan weaving, and Huichol yarn painting. The program includes 3 filmstrips and 3 audiotapes or 1 VHS tape, as well as 3 teacher's guides, 3 reproducible language arts booklets and one poster-sized map.

The Gran Chichimeca: Casa Grandes and the People of the Southwest. Alarion Press.

This program traces the Chichimecan's early nomadic life and recent excavations. Filmstrip, cassette, manual, and wall poster are included for grades 9 and up.

Japanese Art and Architecture. Alarion Press.

Five programs on three videos, a teaching manual and poster are included in this program for grades 9–12.

The Life and Art of William H. Johnson. Reading & O'Reilly.

The social history of the time (1920s–1940s) and Johnson's evolution as an artist are woven together through the use of historic photographs, paintings and music of the period. Includes teacher's guide, video and portfolio of 8 color reproductions of Johnson's work.

Magnificent Minoans. Alarion Press.

The Minoans of Crete developed a great civilization and passed the arts and sciences from the East to Europe. Video or filmstrip and cassette, manual and poster are included for grades 5–10.

Managing the Overseas Assignment. Copeland Griggs Productions.

This video shows how cultural misunderstandings can affect the traveler's ability in a variety of diverse cultures. 30 minutes.

Masks and Face Coverings. Crystal Productions.

This program portrays the many ways human beings have sought to alter, disguise, protect, adorn and immortalize the face. Included in the 80 examples are an Eskimo seal mask, a Peruvian mummy mask, an African helmet mask, a Mixtec mosaic work, an Apache devil mask and contemporary masks. Video or filmstrip and teacher's guide are included.

Tribal Design. Crizmac.

Presents five major cultures that have made significant contributions to the universal body of art. These are: Alaska, New Guinea, pre-Columbian Mexico, Pacific Northwest Coast, and Africa. Each of the 5 units presents the art of one culture.

Voyager Interactive Media Catalogue. Voyager.

Contains information about the laserdisc and computer technology that addresses issues of art in a variety of cultures.

World Folk Art: A Multicultural Approach. Crystal Productions.

This program explores the meaning of folk art and how it has been passed down through history within different cultures often tied by the thread of common themes. Available in 6 sound filmstrips or 2 videocassettes with teacher's guide.

ADDRESSES

Afropop Worldwide
National Public Radio
2025 M Street, N.W.
Washington, DC 20036

Alarion Press
P.O. Box 1882
Boulder, CO 80306

American Forum for Global Education
45 John Street, Suite 908
New York, NY 10038

American Institute for Character Education
Dimension II Building, 8919 Tesoro, Suite 220
San Antonio, TX 78217

Asian Art Museum of San Francisco
Golden Gate Park
San Francisco, CA 94118

Anti-Defamation League of B'nai B'rith
823 United Nations Plaza
New York, NY 10017

Art Image Publications
61 Main Street, P.O. Box 568
Champlain, NY 12919

AT&T Language Line Services
1 Lower Ragsdale Drive, Building 2
Monterey, CA 93940

Bellerophon Books
36 Anacapa Street
Santa Barbara, CA 93101

Boston Globe
The Young Reader
Public Relations Department
P.O. Box 2378
Boston, MA 02107–2378

California State Department of Education
P.O. Box 271
Sacramento, CA 95802–0271

California Tomorrow
Fort Mason Center, Building B
San Francisco, CA 94123

Center for Teaching International Relations
University of Denver
2201 South Gaylord
Denver, CO 80208

Chelsea Curriculum Project
P.O. Box 5186
Yeadon, PA 19050

Children's Museum
300 Congress Street
Boston, MA 02210

Copeland Griggs Productions
302 23rd Avenue
San Francisco, CA 94121

Crizmac Art & Cultural Education Materials
3316 North Chapel
Tucson, AZ 85716

Crystal Productions
Box 2159
Glenview, IL 60055

Dover Publications
31 East 2nd Street
Mineola, NY 11501

Barbara Fehrs-Rampolla
Holmdale High School
Holmdale, NJ 07733

Getty Center for Education in the Arts
401 Wilshire Boulevard, Suite 950
Santa Monica, CA 90401–1455

Global Village
2210 Wilshire Boulevard, Suite 262
Santa Monica, CA 90403

Great Plains National Instructional Television Library
P.O. Box 80669
Lincoln, NE 68501

Greenhaven Press
P.O. Box 289009
San Diego, CA 92198

Interact
Box 997-AH92
Lakeside, CA 92040

Japanese-American Curriculum Project
P.O. Box 1587
San Mateo, CA 94401

Joslyn Art Museum
2200 Dodge Street
Omaha, NE 68102

Knowledge Unlimited
Box 52
Madison, WI 53701–0052

Kunstdame
114 West Denny Way, Suite 286
Seattle, WA 98119

Los Angeles County Museum of Art
5905 Wilshire Boulevard
Los Angeles, CA 90036

Minneapolis Institute of Arts
2400 Third Avenue South
Minneapolis, MN 55404

Modern Talking Picture Service
1 Prudential Plaza, Suite 2020
130 East Randolph Drive
Chicago, IL 60601–6252

Museum of Fine Arts, Boston
465 Huntington Avenue
Boston, MA 02115

Music for Little People
Box 1460
Redway, CA 95560

National Afro-American Museum and
Cultural Center
P.O. Box 578
Wilberforce, OH 45384

National Association for the Education of Young People
1834 Connecticut Avenue, N.W.
Washington, D.C. 20009–5786

National Foundation for the Improvement of Education
1201 16th Street N.W., Suite 628
Washington, D.C. 20036

National Museum of Women in the Arts
1250 New York Avenue, N.W.
Washington, D.C. 20005–3920

National Women's History Project
7738 Bell Road
Windsor, CA 95492–8518

Oxfam
274 Banbury Road
Oxford, OX2 7DZ
England

Philadelphia Museum of Art
Division of Education
P.O. Box 7646
Philadelphia, PA 19101

Program for Art on Film
980 Madison Avenue
New York, NY 10021

Project 10
Fairfax High School
7850 Melrose Avenue
Los Angeles, CA 90046

REACH Center
239 North McLeod
Arlington, WA 98223

Reading & O'Reilly, Inc.
P.O. Box 302, 2 Kensett Avenue
Wilton, CT 06897

Saint Louis Art Museum
Forest Park
Saint Louis, MS 63110–1380

Sandak
70 Lincoln Street
Boston, MA 02111

Seattle Art Museum
Volunteer Park
1400 East Prospect
Seattle, WA 98112

Shorewood Fine Art Reproductions
27 Glen Road
Sandy Hook, CT 06482

Social and Public Art Resource Center
685 Venice Blvd
Venice, CA 90291–4897

Society for Visual Education
1345 Diversy Parkway
Chicago, IL 60614–1299

Teaching Tolerance
400 Washington Avenue
Montgomery, AL 36104

U.S. Committee for UNICEF
331 East 38th Street
New York, NY 10016

Voyager, Inc.
1351 Pacific Coast Highway
Santa Monica, CA 90401

Washington State Arts Commission
Art in Public Places Program
9th and Columbia Building
Olympia, WA 98504

Zephyr Press
3316 N. Chapel Avenue
Tucson, AZ 85732–3448

PARTICIPANTS*

ADVISORY COMMITTEE

Claudine K. Brown, LL.D.
Deputy Assistant Secretary for
Museums
Smithsonian Institution
Washington, D.C.

Judith Madden Bryant
Art Specialist
Portland Public Schools
Portland, OR

Anne P. El-Omami
Curator of Education
Cincinnati Art Museum
Cincinnati, OH

Thandiwee Michael Kendall
Program Officer
Getty Center for Education in the Arts
Santa Monica, CA

Rebecca Orona
Fourth-Grade Classroom
Teacher/Mentor, Visual Arts
Washington Elementary School
Montebello, CA

Peter Pennekamp
Vice President for Cultural Programs
National Public Radio
Washington, D.C.

Vasundhara Prabhu
Director of Education
Museum of Contemporary Art
Los Angeles, CA

*Affiliations, titles, and registration
are accurate as of July 22, 1992.

Martin Rosenberg, Ph.D.
Associate Professor of Art History
University of Nebraska, Omaha
Omaha, NE

Enid Zimmerman, Ph.D.
Professor of Art Education
Indiana University
Bloomington, IN

PRESENTERS

Judith Madden Bryant

F. Graeme Chalmers
Professor of Art Education
University of British Columbia
Vancouver, BC Canada

Gilbert A. Clark
Professor of Art Education
School of Education
Indiana University
Bloomington, IN

Lisa Corrin
Assistant Director
Museum for Contemporary Arts
Baltimore, MD

Vesta A.H. Daniel
Associate Professor
Department of Art
Ohio State University
Columbus, OH

Michael D. Day
Chair & Professor of Art
Harris Fine Arts Center
Brigham Young University
Provo, UT

Jean Detlefsen
Instructor
Columbus High School
Columbus, NE

Ellen F. Dissanayake
Independent Scholar and Visiting
Research Fellow
Institute for Advanced Studies in the
Humanities
University of Edinburgh
Edinburgh, Scotland

Marcia Muelder Eaton
Professor
Department of Philosophy
University of Minnesota
Minneapolis, MN

Anne P. El-Omami

Carl A. Grant
Professor
Department of Curriculum &
Instruction
University of Wisconsin—Madison
Madison, WI

Catherine Leffler
Instructor
Encino Elementary School
Sherman Oaks, CA

Rachel Mason
Head, Centre of Postgraduate
Teacher Education
Leicester Polytechnic
Leicester, England

June King McFee
Professor Emeritus
University of Oregon
Eugene, OR

Janis Norman
Chair, Art Education
University of the Arts
Philadelphia, PA

Peter Pennekamp

Alfred J. Quiroz
Professor
Department of Art
University of Arizona
Tucson, AZ

Bernice Johnson Reagon
Curator, Division of Community Life
National Museum of American
History
Smithsonian Institution
Washington, DC

Martin Rosenberg

Christine E. Sleeter
Associate Professor, Department of
Education
University of Wisconsin, Parkside
Kenosha, WI

Judith Stein
Adjunct Curator
Pennsylvania Academy of the
Fine Arts
Philadelphia, PA

Robert Storr
Curator
Museum of Modern Art
New York, NY

Frances E. Thurber
Assistant Professor of Art Education
Department of Art
University of Nebraska
Omaha, NE

Marianna Torgovnick
Professor, Department of English
Duke University
Durham, NC

Alan Wallach
Ralph H. Wark Professor of Fine Art
College of William & Mary
Williamsburg, VA

Robyn F. Wasson
Manager
Service Industries Studies Branch
Technical and Further Education,
Training, and Employment
South Brisbane, Queensland,
Australia

Brent Wilson
Professor
School of Visual Arts
Pennsylvania State University
University Park, PA

Fred Wilson
Guest Curator
Museum for Contemporary Arts
Baltimore, MD

Enid Zimmerman

PARTICIPANTS

Kay Alexander
Art Education Consultant
Los Altos, CA

Akbar Ali
Project Coordinator
Smithsonian Integrated Curriculum
Development
New York, NY

Debra Barrett
Associate Professor of Art
Florida State University
Tallahassee, FL

Terry Barrett
Associate Professor
Ohio State University
Columbus, OH

Nancy Berry
Assistant Professor of Art
University of North Texas
Dallas, TX

Doug Blandy
Associate Professor of Art
School of Architecture & Allied Arts
University of Oregon
Eugene, OR

Sharon Blume
Deputy Director
American Museum of
the Moving Image
Astoria, NY

Candace Borland
Manager of Client Services
Getty Information Resources
Santa Monica, CA

Mary Katherine Bowers
Instructor
Eugene School District 4J
Eugene, OR

Sheila Brown
Art & Gifted Coordinator
Nebraska Department of Education
Lincoln, NE

Jola Burch
Instructor
Blythe Avenue Elementary School
Cleveland City School District
Cleveland, TN

Ann Byerrum
Director of Arts Education
Yakima School District
Yakima, WA

Susan Cahan
Education Curator
New Museum of Contemporary Art
New York, NY

Kimberly Camp
Director
Experimental Gallery
Smithsonian Institution
Washington, DC

Kellene Champlin
Coordinator of Art Education
Fulton County Board of Education
Atlanta, GA

Jacqueline Chanda
Associate Professor of Art
Ohio State University
Columbus, OH

Lolita Chandler
Vice President & Director of External
Affairs
Macmillan/McGraw Hill
New York, NY

Faith Childs-Davis
Art Instructor
Seattle Public Schools
Seattle, WA

Dorte Christjansen
Associate Professor of Art
California State University
Fullerton, CA

James M. Clarke
President
National Art Education Association
Houston, TX

Faith Clover
Curriculum Specialist
Portland Public Schools
Portland, OR

Carolyn Cochrane
Grant Coordinator
Eugene School District 4J
Eugene, OR

Kristin Congdon
Chair
Community Arts Program
University of Central Florida
Orlando, FL

Lila Crespin
Lecturer
California State University, Long
Beach
Corona Del Mar, CA

D. Jack Davis
Vice Provost
North Texas Institute for Educators in
Visual Arts
University of North Texas
Denton, TX

Rogena M. Degge
Associate Professor of Arts &
Administration
School of Architecture & Allied Arts
University of Oregon
Eugene, OR

Elizabeth Delacruz
Assistant Professor of Art Education
University of Illinois, Urbana—
Champaign
Champaign, IL

Margaret DiBlasio
Head, Art Education Program
University of Minnesota
Saint Paul, MN

Sandy Dilger
Art Consultant
Florida Department of Education
Tallahassee, FL

Stephen Dobbs
President
Marin Community Foundation
Larkspur, CA

Phillip C. Dunn
Associate Professor of Art
University of South Carolina
Blythewood, SC

David Ebitz
Head, Education & Academic Affairs
J. Paul Getty Museum
Santa Monica, CA

Sandra M. Epps
Multicultural Arts Coordinator
Community School District Five
New York, NY

Jill Finsten
Museum Lecturer
J. Paul Getty Museum
Santa Monica, CA

Lynn Galbraith
Assistant Professor of Art Education
University of Arizona
Tucson, AZ

Carlos Galindo
Instructor
Markham Elementary School
Portland, OR

George Geahigan
Associate Professor of Art Education
Purdue University
West Lafayette, IN

Virginia Gembica
Getty Project Coordinator
Manhattan Beach, CA

MacArthur Goodwin
Education Associate of Art
South Carolina Department of
Education
Columbia, SC

Sally Hagaman
Chair & Associate Professor
Department of Art & Design
Purdue University
West Lafayette, IN

Elizabeth S. Hartung
Associate Professor of Art
California State University
Long Beach, CA

Mary Gay Holland
Art Consultant
Eugene School District 4J
Eugene, OR

Edith Johnson
Project Manager
Fresno County Office of Education
Fresno, CA

Phyllis Johnson
Director
Central Valley Institute for Education
in Visual Arts
Fresno, CA

Sheila Judge-Hall
Art Resource Teacher
Art Department
Anchorage School District
Anchorage, AK

Eldon Katter
Professor of Art Education
Kutztown University
Kutztown, PA

Paul W. Kravagna
Professor of Art
California State University
Northridge, CA

Beverly Lamb
Assistant Curator of Education for
Programs
Cincinnati Art Museum
Cincinnati, OH

Richard LaTour
Coordinator, Education Programs
Oregon Department of Education
Salem, OR

Anne Lindsey
Director
Southeast Institute for Education in
the Visual Arts
University of Tennessee
Chattanooga, TN

Genevieve Litecky
Arts in Education Coordinator
Alaska Arts in Education Program
Anchorage, AK

Nancy MacGregor
Director
Ohio Partnership for the Visual Arts
Ohio State University
Columbus, OH

Ron Manook
Secondary Art Teacher
Fairbanks North Star Borough School
District
Alaska State Council on the Arts
Fairbanks, AK

Jill Markey
Instructor
Columbus Public Schools
Columbus, OH

Kathryn A. Martin
Dean, College of Fine & Applied Arts
University of Illinois, Urbana—
Champaign
Champaign, IL

Susan Mayer
Senior Lecturer
Huntington Art Gallery
University of Texas
Austin, TX

R. William McCarter
North Texas Institute for Educators in Visual Arts
University of North Texas
Denton, TX

Nancy McDonald
Art Instructor
Gardena High School
Gardena, CA

Christine McEnespy
Instructor
Institute for Visual Arts Education
Sacramento, CA

Tom McMullen
Director
Minnesota DBAE Consortium
Minneapolis, MN

Bert Menninga
Assistant Director
Education Writers Association
Washington, DC

Ronald Moore
Director, Center for the Humanities
Associate Professor of Philosophy
University of Washington
Seattle, WA

Carol Morgan
Acting Director, Department of Education
Museum of Modern Art
New York, NY

Elaine Morgan
Instructor
Columbus Public Schools
Columbus, NE

Sally Myers
Assistant Professor
Ball State University
Department of Art
Muncie, IN

Sandra Noble
Fine Arts Curriculum Specialist
Cleveland Public Schools
Cleveland, OH

Joan Peterson
Consultant
California Department of Education
Sacramento, CA

Bonnie Pitman
Deputy Director
University Art Museum
University of California, Berkeley
Berkeley, CA

Marilyn Price-Richard
Assistant Professor
Department of Art
Ball State University
Muncie, IN

Suzy Reid
Instructor
Eastern Hills Elementary School
Fort Worth, TX

Nancy Reynolds
Project Coordinator
North Texas Institute for Educators in Visual Arts
University of North Texas
Denton, TX

Wade Richards
Museum Educator
J. Paul Getty Museum
Santa Monica, CA

Jean C. Rush
Professor, Department of Art
Illinois State University
Normal, IL

Robert Russell
Chair & Associate Professor
School of Art
University of Cincinnati
Cincinnati, OH

Katherine Schwartz
Adjunct Faculty
Kenai Peninsula College
University of Alaska
Soldotna, AK

Maurice Sevigny
Dean
School of Fine Arts
University of Arizona
Tucson, AZ

Pamela Sharp
Associate Professor
College of Art & Design
San Jose State University
San Jose, CA

Carolyn Sherburn
Art Instructor
Burton Hill Elementary School
Fort Worth, TX

Terry Stevenson
Instructor
Dade Elementary School
Chattanooga, TN

Marilyn G. Stewart
Assistant Provost
Kutztown University
Kutztown, PA

Kathy Suzuki
Art Instructor
Robbinsdale Public Schools
Minneapolis, MN

Mark Thistlethwaite
Associate Professor of Art History
Texas Christian University
Fort Worth, TX

Roger Tomhave
Art Curriculum Specialist
Fairfax County Public Schools
Annandale, VA

Chris Tonsmeire
Instructor
Killearn Lakes Elementary School
Tallahassee, FL

Robyn Turner
Art Consultant
Austin, TX

Isabel White
Art Instructor
Many Farms Elementary School
Window Rock, AZ

Harold M. Williams
President
J. Paul Getty Trust
Santa Monica, CA

Amy Wilson
Instructor
George Middle School
Portland, OR

Joyce Wright
Director
Institute for Visual Arts Education
Sacramento County Office of
Education
Sacramento, CA

Georgia Zweber
Senior Technical Trainer
Getty Information Resources
Santa Monica, CA

GETTY CENTER DOCTORAL FELLOWS

Constance M. Bumgarner
Pennsylvania State University
State College, PA

Dan Dunnahoo
University of Georgia
Zebulon, GA

Angie Galipault
Ohio State University
Columbus, OH

Sharon Gray
Brigham Young University
Orem, UT

Jonathan Matthews
Stanford University
Palo Alto, CA

Robert Sabol
Indiana University
Crawfordsville, IN

Stephen Shipps
Harvard Graduate School of
Education
Cambridge, MA

Susan Slavik
Florida State University
Northville, MI

Jan Elfine Zimmerman
Illinois State University
Bloomington, IL

GETTY CENTER FOR EDUCATION IN THE ARTS STAFF

Ann Bassi
Program Officer

Leilani Lattin Duke
Director

Thandiwee Michael Kendall
Program Officer

Juliet Moore
Intern

Elizabeth Paul
Senior Program Associate

Vicki Rosenberg
Program Officer

Mary Ann Stankiewicz
Program Officer

Kathy Talley-Jones
Managing Editor

CONFERENCE COORDINATION

Alexis Anderson
Junior Account Executive
Pacific Visions Communications
Los Angeles, CA

Mary Day
Senior Secretary
Getty Center for Education in the Arts

Valsin A. Marmillion
President
Pacific Visions Communications
Los Angeles, CA

Mark Zipoli
Senior Secretary
Getty Center for Education in the Arts

PROCEEDINGS CREDITS

Seminar summaries prepared by
Keens Company, Falls Church, VA
William Keens, President and Project
Director

Recorders: Diane Bellissimo, Rebecca
Brooks, Heather Lacy, Robin Maca,
Susana Monteverde, Cheryl Rae, Eliza
Reilly, Donna Love Vliet

Kathy Talley-Jones
Manager of Publications
Getty Center for Education in the Arts

Amy Armstrong
Production Coordinator
J. Paul Getty Trust Publication
Services

Eileen Delson: Designer

Kathi George: Copy Editor

Adrienne Lee
Senior Secretary
Getty Center for Education in the Arts

Juliet Moore, Rebecca Orona:
Resources

Douglas Mazonowicz: Illustrations